T0268685

FRUIT

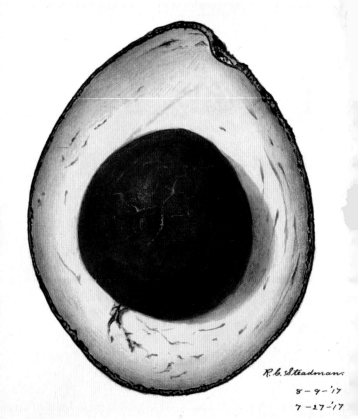

R.C. Steadman.

8-9-'17

7-17-'17

FRUIT

FROM THE USDA POMOLOGICAL WATERCOLOR COLLECTION

By Lee Reich, PhD

A TINY FOLIO™
Abbeville Press Publishers
New York London

Front cover: Baldwin apple (*Malus domestica*). See page 20.
Back cover: Weymouth blueberry (*Vaccinium corymbosum*). See page 233.
Page 2: Carabou avocado (*Persea americana*). See page 268.
Page 6: Peasgood Nonesuch apple (*Malus domestica*). See page 78.
Page 12: Red Delicious apple (*Malus domestica*). See page 86.
Page 114: Doyenne du Comice pear (*Pyrus communis*). See page 123.
Page 136: Lambert cherry (*Prunus avium*). See page 146.
Page 198: Jaffa orange (*Citrus sinensis*). See page 215.
Page 226: Marsala grape (*Vitis* sp.). See page 241.
Page 264: Pomegranate (*Punica granatum*). See page 280.

Editor: Lauren Bucca
Copy editor: Maia Vaswani
Layout: Misha Beletsky and Marina Drukman
Production manager: Louise Kurtz

The images herein are from the US Department of Agriculture Pomological Watercolor Collection, Rare and Special Collections, National Agricultural Library, Beltsville, MD 20705.

First edition
10 9 8 7 6 5 4 3 2 1

ISBN 978-0-7892-1427-0

Library of Congress Cataloging-in-Publication Data available upon request

For bulk and premium sales and for text adoption procedures, write to Customer Service Manager, Abbeville Press, Inc., 655 Third Avenue, New York, NY 10017, or call 1-800-ARTBOOK.

Visit Abbeville Press online at www.abbeville.com.

CONTENTS

Cultivars of a fruit are presented in alphabetical order.

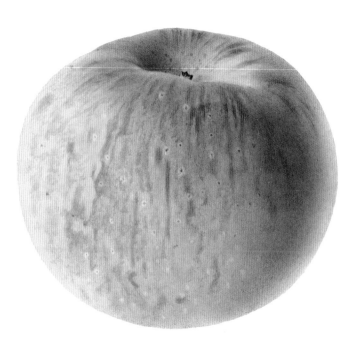

INTRODUCTION

I t's no surprise that an apple—some people contend it was a quince or a fig, but a fruit, at any rate—provided the enticement in the Garden of Eden. Just look at the beauty of most fruits! And, to make things better (or worse, depending on your perspective), they sit there dangling their enticement from the branches. I'd pick one. And I have.

Of course, the pleasure fruits offer is more than skin deep. Their flavors and textures are as varied as their physical beauty.

On the pages that follow you'll find a number of kinds and varieties (a.k.a. "cultivars") of fruits illustrated—250 of them. They are watercolors that were painted by artists commissioned by none other than the United States Department of Agriculture (USDA). Why?

Let's backtrack to when fruit growing in America was still in its infancy. Early European settlers brought with them varieties of their favorite fruits. Often they brought seeds; fruits of the resulting seedling trees were mostly fermented for drink (safer than the day's water) and fed to pigs. Fruits traveled west with homesteaders,

missionaries, and traders—as plants, as stems for grafting or rooting, and as seeds.

Expansion of fruit growing most often relied on seeds because they were less expensive and easiest to pack. The most famous sower of all was Jonathan Chapman, better known as Johnny Appleseed, who traveled far and wide lugging his burlap bag of apple seeds to spread on his travels. Seedlings also sprang up from apple cores and peach pits tossed casually along roadsides. Seedlings that bore fruit deemed noteworthy, whether randomly poking up through the ground or deliberately sown, became new varieties whose names often reflected the name of the sower or location of the first tree. New varieties could then be multiplied from stems that were either rooted or grafted.

Around the middle of the nineteenth century, some Americans began to take more pride in their fruits, not only the varieties carried here from foreign lands and the chance seedlings that were good enough to get a name, but also some of the native fruits. The passion was evident in the words of Louis Berckmans, famous horticulturalist of the nineteenth century, who wrote in 1857: "Let us now have our native varieties of all kinds of fruit. Already the pear, the strawberry, the raspberry, and chiefly the apple, have come in handsome competition with, or superseded, their European relative varieties. We never could see, after those successful experiments, what could prevent us from having just as fine

gooseberries, grapes, etc, and better, too, than the transatlantic products. Gentlemen amateurs! do try all kinds of seedlings; the Phoenix is yet in its 'ashes.' Patience alone and 'eternal vigilance' can only bring out the desired results."

Nurserymen (yes, they were mostly men) increasingly began to offer and promote varieties of fruits for eating—by humans! These varieties needed to be identified correctly.

The US government stepped in to help, with Congress establishing in 1886 the Division of Pomology (fruit growing) and initiating the Program of Pomological Watercolors. Between 1887 and 1942, a total of twenty artists produced 7,100 watercolors; 1,700 more were added later. The bulk of the illustrations reflected the work of eight artists, six of whom were women, with about half of the artwork done by only three of them: Deborah Griscom Passmore, Amanda Almira Newton, and Mary Daisy Arnold.

It wasn't only the US government that stepped up to identify and promote fruit varieties. On my kitchen wall hang some colorful illustrations of fruit varieties developed by early twentieth-century fruit breeder Luther Burbank. In my bookcase sit *The Pears of New York, The Cherries of New York,* and other volumes of the early twentieth century from the New York State Agricultural Experiment Station, all thick volumes profusely illustrated in color. There are also pen-and-ink drawings and descriptions of fruit varieties in Andrew Jackson Downing's *The Fruits and Fruit-Trees of America* (1870).

The Pomological Watercolors were created and shared for both promotional and educational purposes. An illustration with a name attached could better ensure that a Baldwin apple tree sold by a nursery in Iowa was, in fact, the same variety as a Baldwin tree sold by a nursery in Michigan. The same could be said for a particular variety of fruit sold at a local farm stand.

To a point, that is, because not all of the illustrations were accurately labeled. Not being pomologists, the artists labeled the fruits the way they were received. These fruits came from people all over the country—some even from foreign countries—and from people who included nurserymen, farmers, fruit researchers, and home orchardists. And some fruits were uniquely named; my guess is that Ned apple, painted in 1896, probably started life as a seedling that sprouted on the farm or in the garden of someone named Ned.

Many of the illustrations were included in instructional pamphlets geared to farmers or gardeners. That the illustrations were for more than just decoration is attested by the inclusion of illustrations showing fruits with flaws from disease, insects, or inimical weather.

It's natural to question the significance of the old watercolors in these days of high-quality photographs easily disseminated in hard copy and electronically, and markets regularly flooded with new fruit varieties. I, for one, can't help but be wowed by the number of different varieties grown in decades past. Most are no longer readily

available. Some are lost forever. Some might be found again and might be worth bringing back, if not by commercial orchardists, perhaps by backyard fruit growers.

The varieties' names have a quaintness usually lacking in modern varieties. I would reach for a Peasgood Nonesuch or Peck's Pleasant apple (pages 78 and 79), a Neva Myss peach (page 179), or (dare I say it?) a Nuns Thigh pear (page 128) from a supermarket shelf. They may or may not have good flavor, but their intriguing names make them worth a bite.

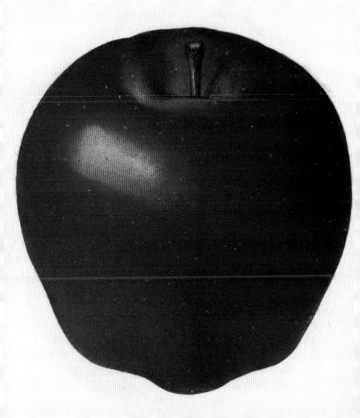

1

APPLES

Why are apples first in this book, and why is a whole chapter devoted to this one fruit? Because way back when, they were the first fruit, of course. No! Apples are not the longest cultivated of fruits; they're not even the number one fruit consumed in the United States or the world. Still, they are abundant in markets, available year-round, genetically very diverse, and, as you shall see, very beautiful.

Not that apples are newcomers to cultivation. Apple growing dates back to the second millennium BCE in Mesopotamia and Asia Minor. By Roman times, better clones were identified, and apples spread with the spread of the Roman Empire.

Cultivated apples (*Malus domestica*), native to the mountains of Kazakhstan, reached our shores with the first colonists. They then traveled across the country with settlers as seedling trees, scions of varieties for grafting, and as seeds.

Over 7,500 varieties of apples exist. The watercolors highlight the greater diversity of varieties grown around the early twentieth century. Particularly popular, often regionally or locally, were varieties such as Ben Davis, Esopus Spitzenberg, Jonathan, Rhode Island Greening, and Roxbury Russet (pages 25, 44, 59, 89, and 92).

And what names they had! How popular would a variety named Red Democrat (page 87) be today? Could you resist sinking your teeth into an apple named Seek-No-Further (page 51)?

Stories accompany many of the varieties. Newtown Pippin (page 75), renamed Albemarle Pippin in the South, originated in Newtown, New York (later named Elmhurst, a part of Queens). It was so popular that Benjamin Franklin had Newtown Pippins shipped to him in England. Queen Victoria became an ardent fan.

Baldwin apple (page 20), one of the most widely planted varieties in the northeast, was painted thirty-four times before 1934; then, abruptly, no further illustrations of this variety appear. Why? The particularly cold winter of 1934 killed two-thirds of the trees and put a quick end to the variety's commercial popularity.

Red Delicious began life as a seedling tree on the farm of Jesse Hiatt of Peru, Iowa, first fruiting in the 1870s. He named this deliciously sweet, blushed, yellow apple Hawkeye (page 52). Jesse entered the fruit into a contest. He won, and sold the rights to propagate the tree to the contest sponsor, Stark

Brothers Nursery, who renamed it Starking Delicious, later renamed Red Delicious to distinguish it from Golden Delicious.

Flip forward to the watercolor of Hawkeye; it bears little resemblance to today's Red Delicious in color or shape. Red Delicious tends to "sport"; that is, a bud may mutate slightly to become a branch bearing fruits slightly different from the rest of the tree. Over time, growers sought Delicious sports whose fruits were more and more elongated and, overall, a deep red color. This is evident if you compare the illustrations labeled Hawkeye, Red Delicious, and Red Delicious Sport (pages 52, 86, and 40). (Over the years, numerous sports have been identified and patented.) Flavor was sacrificed for appearance, but by the middle of the twentieth century, apples were becoming more of a commodity, appealing to consumers' eyes rather than their taste buds.

Returning to apple's "roots": the word "apple" probably traces its origin to the Proto-Indo-European *æppel*, which could refer not only to apple but to any kind of fruit, a meaning that carried on to early modern English in the seventeenth century, except for berries.

Apple's generic name Malus goes back to the Latin *mālum,* meaning any fleshy tree fruit with a kernel. The apple arrived in the Garden of Eden via a confusion or a play on words in the Bible's translation into Latin by Saint Jerome in the fourth century, between *mālum* and *malum* (with a short "a"), meaning "evil."

Nonetheless, based on flavor and beauty, I'd give *Malus domestica* that prominent role in the Garden of Eden.

All Purpose apple
(*Malus domestica*),
Guilford, North
Carolina, 1900
Deborah Griscom
Passmore (1866–1956)

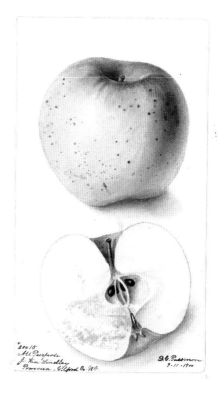

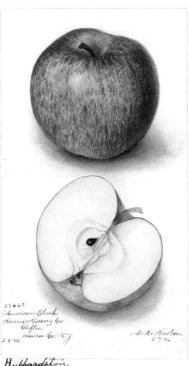

American Blush
apple (*Malus domestica*),
Monroe, New York,
1906
Amanda Almira Newton
(c. 1860–1943)

American Limbertwig apple (*Malus domestica*), Wilkes, North Carolina, 1916
Royal Charles Steadman (1875–1964)

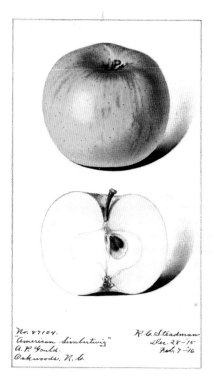

No. 87104.
"American Limbertwig"
A. P. Gould.
Oakwoods, N.C.

R. C. Steadman
Dec. 28 -'15
Feb. 7 -'16

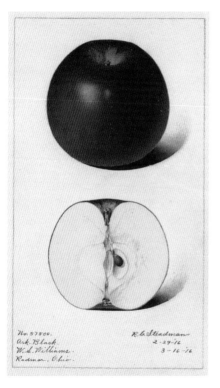

Arkansas Black apple
(*Malus domestica*),
Radmor, Ohio, 1916
Royal Charles Steadman
(1875–1964)

Baldwin apple (*Malus domestica*), Ionia, Michigan, 1915
Royal Charles
Steadman (1875–1964)

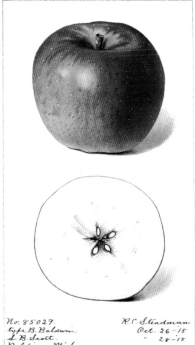

No. 85029.
type B. Baldwin
L. B. Scott.
Belding. Mich.

R. C. Steadman
Oct. 26 -15
" 28 -15

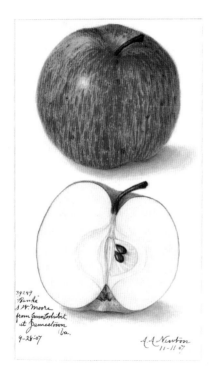

Banks apple (*Malus domestica*), Prince Edward, Virginia, 1907
Amanda Almira Newton
(c. 1860–1943)

39249
Banks
S. W. Moore
from Jamestown
at Jamestown
Va.
9-28-07

A A Newton
11-11-07

Beacon apple (*Malus domestica*), Ramsey, Minnesota, 1938
Deborah Griscom Passmore (1866–1956)

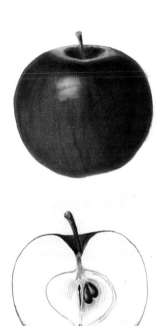

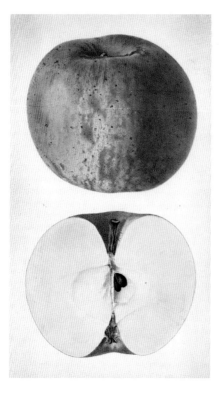

Belle de Bokskoop
apple (*Malus domestica*),
Arlington, Virginia,
1924
Royal Charles Steadman
(1875–1964)

Belmont apple
(*Malus domestica*),
Uintah, Utah, 1911
Amanda Almira
Newton (c. 1860–1943)

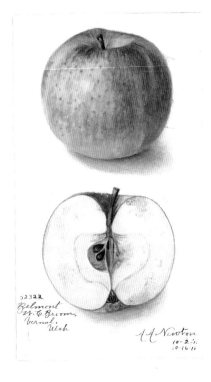

52322
Belmont
W. E. Broom,
Vernal,
Utah

A. A. Newton
10-2-11,
10-16-11

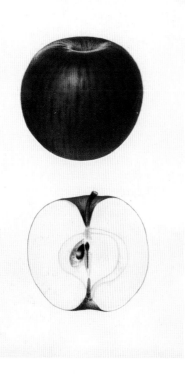

Ben Davis apple
(*Malus domestica*), Clay,
Illinois, 1933
Mary Daisy Arnold
(1873–1955)

Black Oxford apple
(*Malus domestica*),
Polk, Iowa, 1896
Deborah Griscom
Passmore (1866–1956)

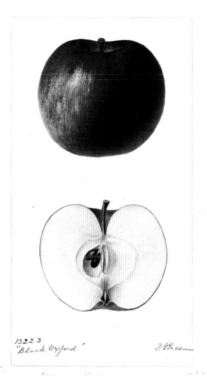

Blenheim Orange
apple (*Malus domestica*),
1931
Mary Daisy Arnold
(1873–1955)

Bloodless Seedless apple (*Malus domestica*), Albemarle, Virginia, 1907 Deborah Griscom Passmore (1866–1956)

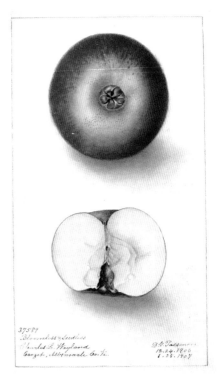

37589
Bloodless & Seedless
Charles L. Wayland
Crozet, Albemarle Co. Va.

D. G. Passmore
12.24.1906
1.25.1907

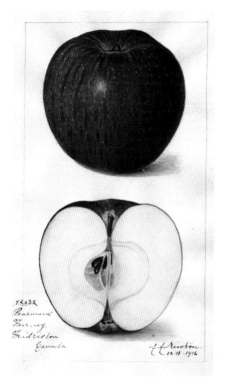

Blue Pearmain apple
(*Malus domestica*),
Canada, 1916
Amanda Almira Newton
(c. 1860–1943)

29

Bottle Greening apple
(*Malus domestica*),
Monmouth, New
Jersey, 1913
Amanda Almira
Newton (c. 1860–1943)

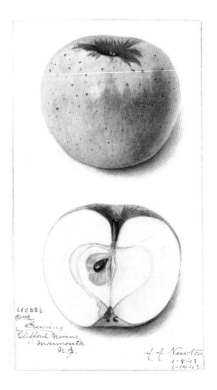

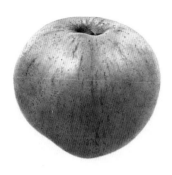

Bradley apple (*Malus domestica*), 1931
Mary Daisy Arnold
(1873–1955)

Calville Blanc
d'Hiver apple (*Malus
domestica*), Yakima,
Washington, 1932
Mary Daisy Arnold
(1873–1955)

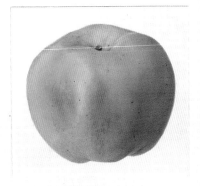

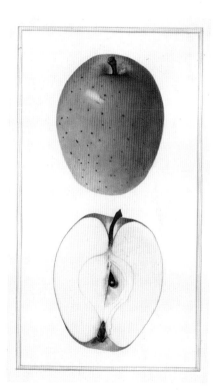

Candil Sinap apple
(*Malus domestica*),
Arlington, Virginia, 1925
Mary Daisy Arnold
(1873–1955)

Cheese of Pennsylvania
apple (*Malus
domestica*), Kernstown,
Pennsylvania, 1915
M. Strange

81346
Cheese of Pa.
G A Wigginton
Kernstown.
Pa.

M Strange.
4 - 7 - 15.
4 - 19 - 15.

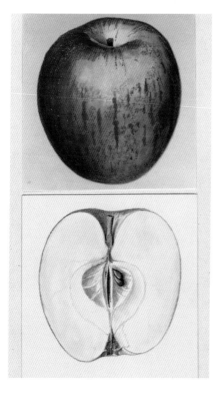

Chenango apple
(*Malus domestica*), Story,
Iowa, 1937
L. C. Krieger
(1873–1940)

Children's
Delight apple
(*Malus domestica*),
Montgomery,
Maryland, 1899
Deborah Griscom
Passmore (1866–1956)

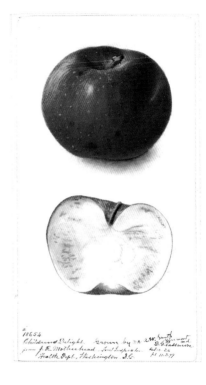

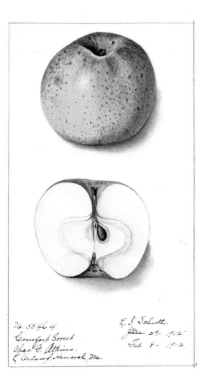

Comfort Sweet apple
(*Malus domestica*),
Hancock, Maine, 1912
Ellen Isham Schutt
(1873–1955)

No. 55464
Comfort Sweet
Chas. G. Atkins.
& Orland, Hancock, Me.

E. I. Schutt.
Dec 2d 1912
Feb 8 - 1912

Cortland apple
(*Malus domestica*),
Bennington,
Vermont, 1937
Mary Daisy Arnold
(1873–1955)

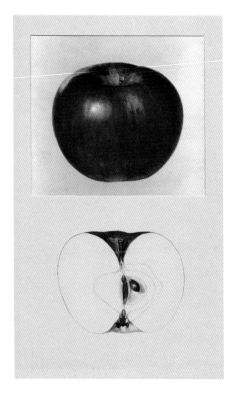

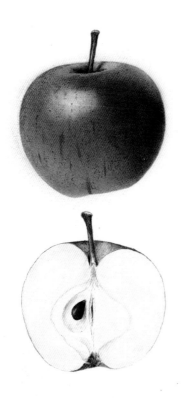

Cox Orange
Pippin apple (*Malus
domestica*),
England, 1931
Mary Daisy Arnold
(1873–1955)

Dark Red Delicious Sport apple (*Malus domestica*), Yakima, Washington, 1932 Mary Daisy Arnold (1873–1955)

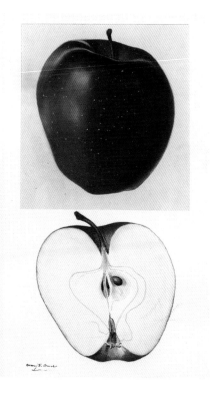

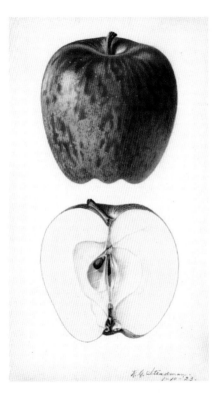

Delicious apple (*Malus domestica*), Sonoma, California, 1923
Royal Charles Steadman
(1875–1964)

Doctor Matthews
apple (*Malus
domestica*), Lawrence,
Indiana, 1916
Royal Charles
Steadman (1875–1964)

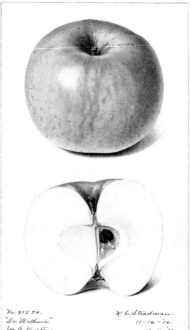

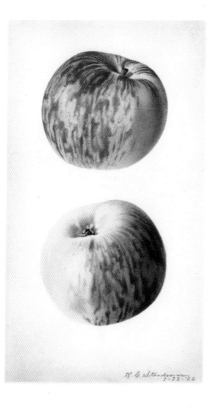

Duchess of Oldenburg
apple (*Malus domestica*),
Montgomery,
Maryland, 1922
Royal Charles Steadman
(1875–1964)

Esopus Spitzenberg
(*Malus domestica*),
Australia, 1905
Bertha Heiges
(1866–1956)

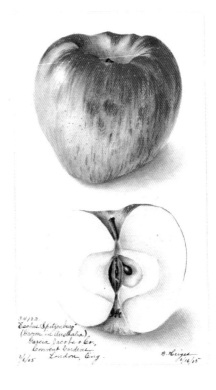

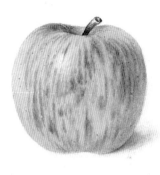

Frazers Hard Skin
apple (*Malus domestica*),
Sangamon, Illinois, 1897
Deborah Griscom
Passmore (1866–1956)

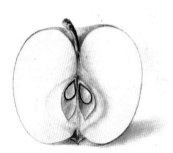

Gills Beauty apple
(*Malus domestica*),
Sangamon, Illinois,
1897
Deborah Griscom
Passmore (1866–1956)

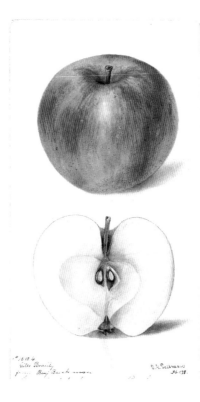

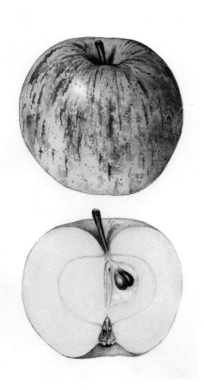

Gladstone apple
(*Malus domestica*),
Arlington, Virginia, 1921
Mary Daisy Arnold
(1873–1955)

47

Golden Delicious apple
(*Malus domestica*),
Pike, Missouri, 1920
Amanda Almira
Newton (c. 1860–1943)

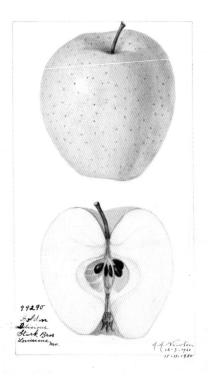

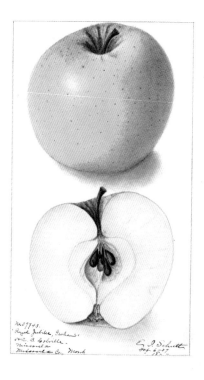

Graham Jubilee
apple (*Malus domestica*),
Missoula, Montana,
1907
Ellen Isham Schutt
(1873–1955)

Gravenstein apple
(*Malus domestica*),
Albermarle, Virginia,
Amanda Almira
Newton (c. 1860-1943)

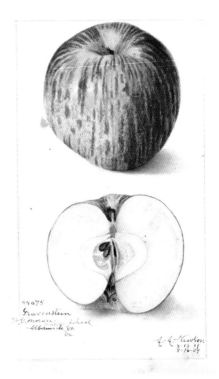

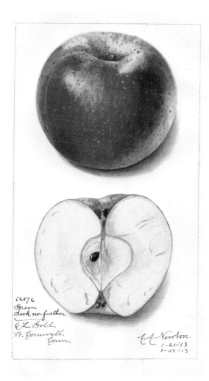

Green Seek-No-Further
(*Malus domestica*),
Litchfield,
Connecticut, 1913
Amanda Almira Newton
(c. 1860–1943)

Hawkeye apple (*Malus domestica*), Story, Iowa, 1938
Mary Daisy Arnold (1873–1955)

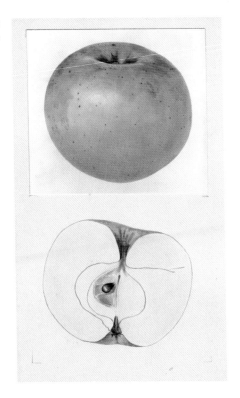

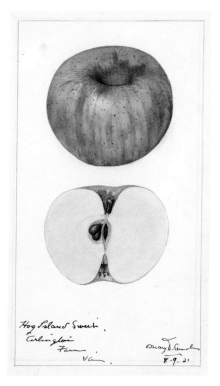

Hog Island Sweet apple
(*Malus domestica*),
Rosslyn, Virginia, 1921
Mary Daisy Arnold
(1873–1955)

Hog Island Sweet.
Arlington
Farm.
Va.

Mary D. Arnold
8-9-21

Honest John apple
(*Malus domestica*),
Page, Virginia, 1899
Bertha Heiges
(1866–1956)

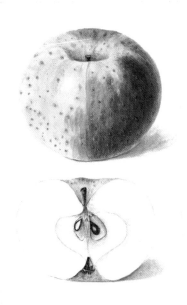

#18595
"Honest John"
from B. Heiges
 U. Bolen, Kimball, Page Co., Va. 10/2/99
10/20/99

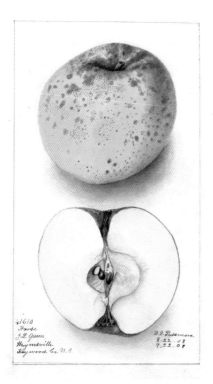

Horse apple (*Malus domestica*), Haywood, North Carolina, 1908
Deborah Griscom Passmore (1866–1956)

Hubbardston
Nonsuch apple (*Malus
domestica*), Arlington,
Virginia, 1928
Mary Daisy Arnold
(1873–1955)

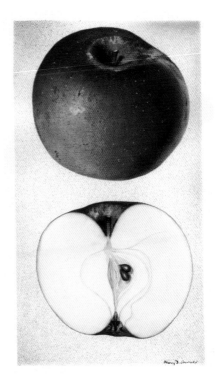

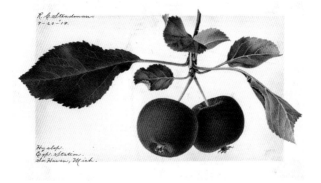

Hyslop apple (*Malus domestica*), Van Buren, Michigan, 1919
Royal Charles Steadman (1875–1964)

Jacobs Sweet apple
(*Malus domestica*),
New York, 1898
Bertha Heiges
(1866–1956)

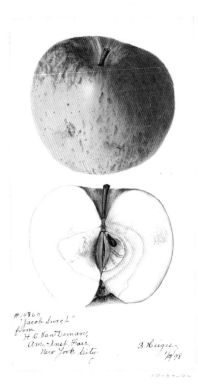

#14860
"Jacob Sweet"
from
H. E. Van Deman,
Am. Inst. Fair,
New York City. B. Heiges,
 1/98

Jonathan apple
(*Malus domestica*),
New Zealand, 1935
James Marion Shull
(1872–1948)

Juicy Bite apple (*Malus domestica*), Johnson, Nebraska, 1896 Deborah Griscom Passmore (1866–1956)

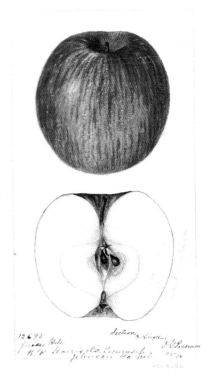

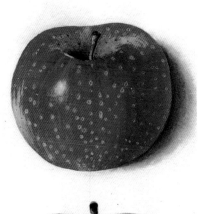

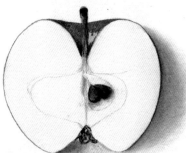

Kittagaskee apple
(*Malus domestica*),
Arlington,
Virginia, 1925
Mary Daisy Arnold
(1873–1955)

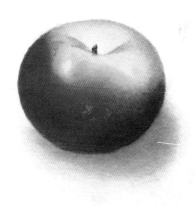

Lady apple
(*Malus domestica*),
Nelson, Virginia, 1910
Deborah Griscom
Passmore (1866–1956)

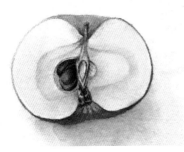

Landakergska apple
(*Malus domestica*),
Prince George's,
Maryland, 1939
L. C. Krieger
(1873–1940)

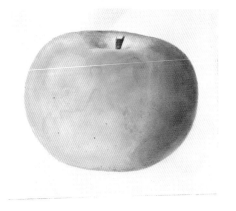

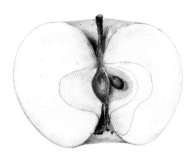

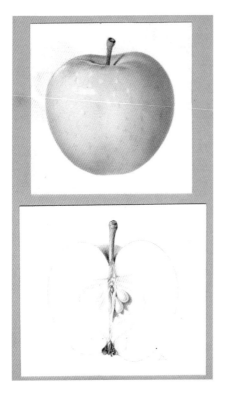

Lodi apple (*Malus domestica*), Prince George's, Maryland, 1937
James Marion Shull
(1872–1948)

Loveland Raspberry
apple (*Malus
domestica*),
Canada, 1909
Ellen Isham Schutt
(1873–1955)

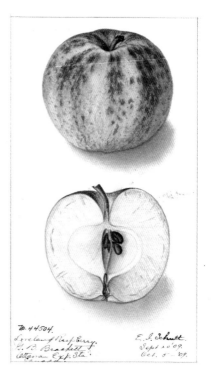

No. 44504.
Loveland Raspberry.
G. B. Brackett +
Ottawa Exp. Sta.
Canada.

E. I. Schutt.
Sept 10 '09.
Oct. 5 - '09.

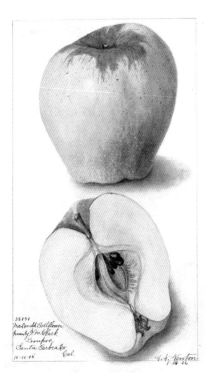

MacDonald
Bellflower apple
(*Malus domestica*),
Santa Barbara,
California, 1906
Amanda Almira Newton
(c. 1860–1943)

Macoun apple
(*Malus domestica*),
New York, 1936
Mary Daisy Arnold
(1873–1955)

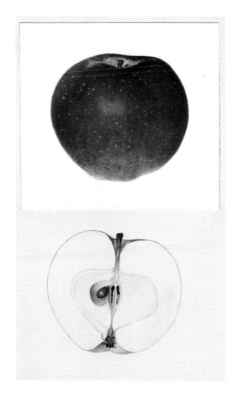

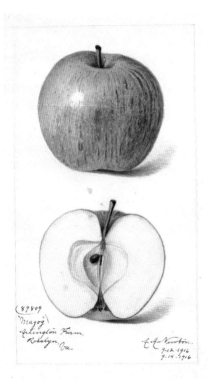

Magog apple (*Malus domestica*), Arlington, Virginia, 1916
Amanda Almira Newton
(c. 1860–1943)

(89809)
"Magog"
Arlington Farm,
Rosslyn, Va.

A. A. Newton.
9-12-1916
9-15-1916

McIntosh apple (*Malus domestica*), Chelan, Washington, 1931
Mary Daisy Arnold
(1873–1955)

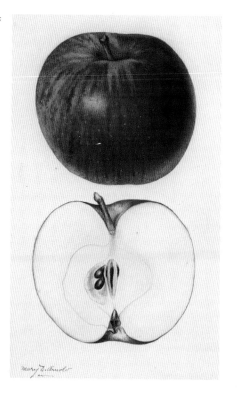

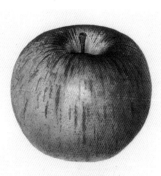

Melba apple (*Malus
domestica*), Middlesex,
New Jersey, 1924
Mary Daisy Arnold
(1873–1955)

105903
Melba
a. J. Farley
Exp. Stat.
new Brunswick, 3 J.

M. D. Arnold

Milton apple
(*Malus domestica*),
Bennington,
Vermont, 1934
Mary Daisy Arnold
(1873–1955)

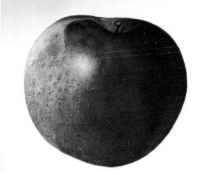

Missing Link apple
(*Malus domestica*),
Wyoming,
Pennsylvania, 1909
Amanda Almira Newton
(c. 1860–1943)

Munson Sweet apple (*Malus domestica*), Arlington, Virginia, 1920 Amanda Almira Newton (c. 1860–1943)

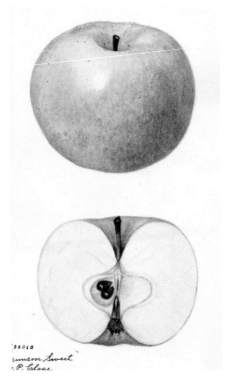

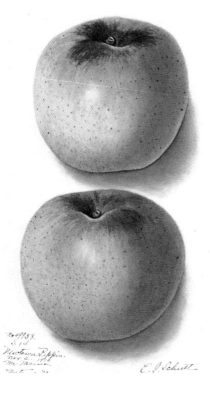

Newtown Pippin
(*Malus domestica*), Santa
Cruz, California, 1910
Ellen Isham Schutt
(1873–1955)

No.4993B.
Sid.
Newtown Pippin.
Nov 2. 1910
Mr. Mann.

E. J. Schutt

Olympia apple
(*Malus domestica*),
Wayne, Ohio, 1905
Deborah Griscom
Passmore (1866–1956)

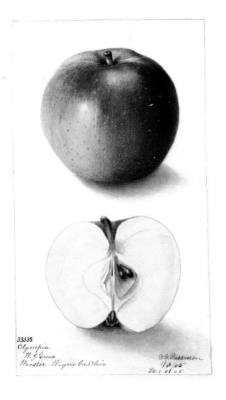

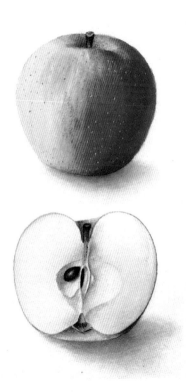

Orleans Reinette apple
(*Malus domestica*),
France, 1900
Deborah Griscom
Passmore (1866–1956)

Peasgood Nonesuch
apple (*Malus
domestica*), Arlington,
Virginia, 1926
Royal Charles
Steadman (1875–1964)

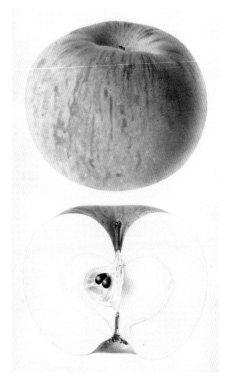

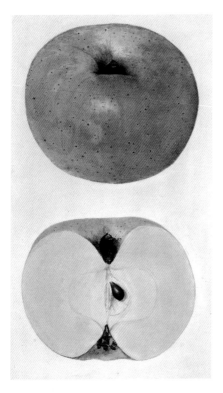

Peck's Pleasant apple
(*Malus domestica*),
Arlington, Virginia, 1925
Mary Daisy Arnold
(1873–1955)

Pilot apple
(*Malus domestica*),
Washoe, Nevada, 1903
Deborah Griscom
Passmore (1866–1956)

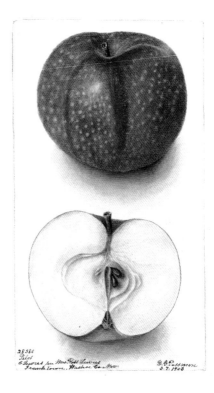

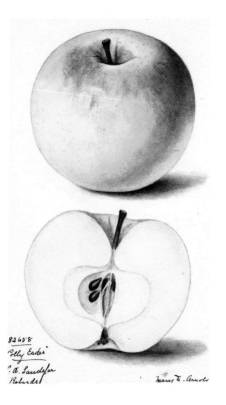

Polly Eades apple
(*Malus domestica*),
Henderson, Kentucky,
1915
Mary Daisy Arnold
(1873–1955)

82658
"Polly Eades"
C. A. Saudefer
Robards

Mary D. Arnold

Pomme de Fer apple (*Malus domestica*), Santa Cruz, California, 1906 Amanda Almira Newton (c. 1860–1943)

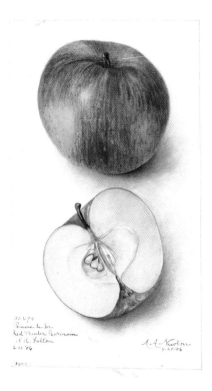

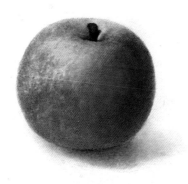

Pomme Gris
apple (*Malus domestica*),
Dutchess, New York,
1905
Deborah Griscom
Passmore (1866–1956)

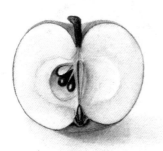

Poorhouse apple
(*Malus domestica*),
Clark, Georgia, 1915
Royal Charles
Steadman (1875–1964)

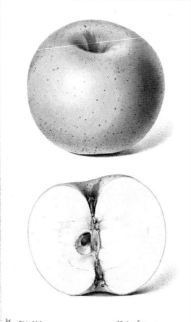

No. 84116.
"Poorhouse."
J. W.ᵐ Firor.
Athens. Ga.

R. C. Steadman.
Oct. 29 – '15
" 30 – '15

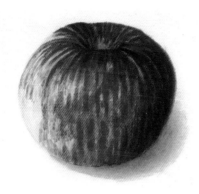

Popoff Streaked
apple (*Malus domestica*),
Davidson, Tennessee,
1910
Amanda Almira Newton
(c. 1860–1943)

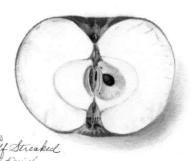

'63
off Streaked

Red Delicious apple (*Malus domestica*), Yakima, Washington, 1932
Mary Daisy Arnold
(1873–1955)

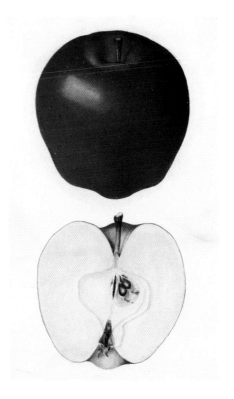

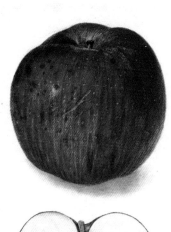

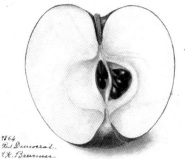

Red Democrat
apple (*Malus domestica*),
Wake, North Carolina,
1899
Deborah Griscom
Passmore (1866–1956)

1864
Red Democrat
F.H. Baumer

Red Twenty-Ounce
apple (*Malus
domestica*), Ontario,
New York, 1935
L. C. Krieger
(1873–1940)

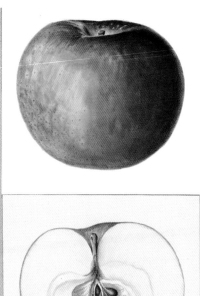

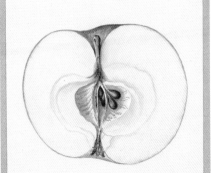

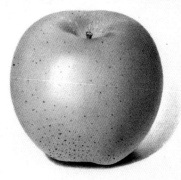

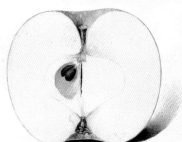

Rhode Island Greening
apple (*Malus domestica*),
1916
Royal Charles Steadman
(1875–1964)

No. 88085.
R.I. Greening.
Frank A. Reynolds

R.C. Steadman
3-22-16
3-30-16

Ribston Pippin apple
(*Malus domestica*),
Canada, 1917
Royal Charles
Steadman (1875–1964)

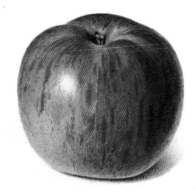

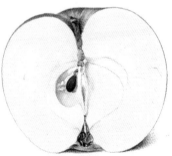

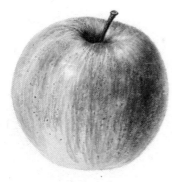

Richards Graft
apple (*Malus domestica*),
Columbia, New York,
1894
Deborah Griscom
Passmore (1866–1956)

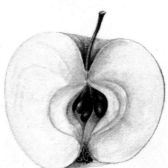

Roxbury Russet apple
(*Malus domestica*),
Wayne, Ohio, 1912
Ellen Isham Schutt
(1873–1955)

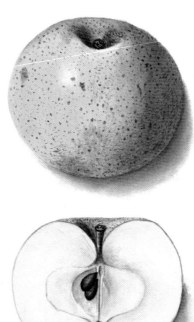

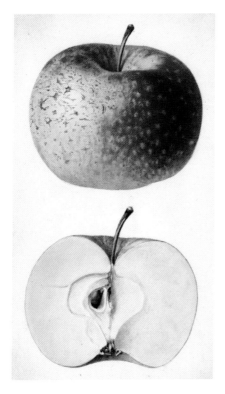

Smokehouse apple
(*Malus domestica*),
Arlington, Virginia, 1923
Royal Charles Steadman
(1875–1964)

Sphinx apple (*Malus domestica*), Chelan, Washington, 1922 Royal Charles Steadman (1875–1964)

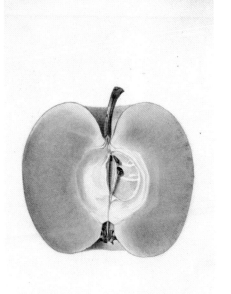

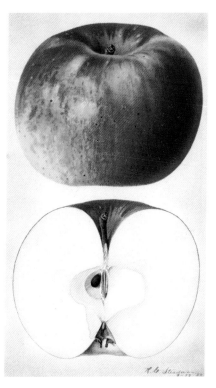

Summer Rambo
apple (*Malus domestica*),
Bucks, Pennsylvania,
1925
Royal Charles Steadman
(1875–1964)

Swear apple
(*Malus domestica*),
Washington, DC, 1907
Deborah Griscom
Passmore
(1866–1956)

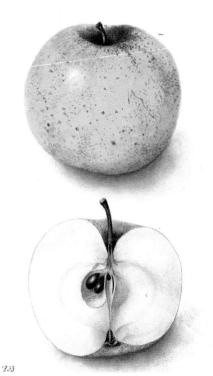

Sweet Bough apple (*Malus domestica*), Van Buren, Michigan, 1919
Royal Charles Steadman (1875–1964)

Tetovka apple (*Malus domestica*), Van Buren, Michigan, 1918
Royal Charles Steadman (1875–1964)

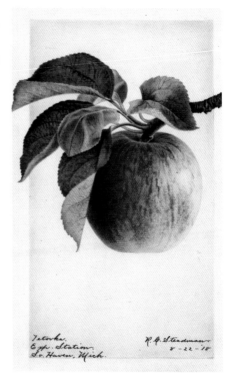

Tewksbury (Winter Blush) apple (*Malus domestica*), Cumberland, Pennsylvania, 1894 William Henry Prestele (1838–1895)

1870.
Tewksbury (Winter Blush)
from Hardy S. Kieffe

Tinmouth
apple (*Malus
domestica*), Addison,
Vermont, 1900
Deborah Griscom
Passmore (1866–1956)

Tolman Sweet apple
(*Malus domestica*),
Hampshire,
Massachusetts, 1921
Royal Charles Steadman
(1875–1964)

Tom Blake
Hard Times apple
(*Malus domestica*),
Virginia, 1909
Ellen Isham Schutt
(1873–1955)

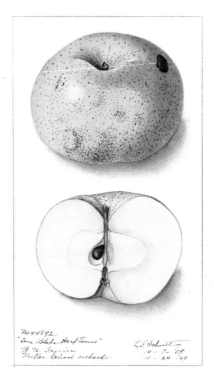

No 44892.
"Tom Blake Hard Times"
W. Va. Virginia
Miller School orchard.

Ellen Schutt
10 - 7- '09
11 - 24 '09

102

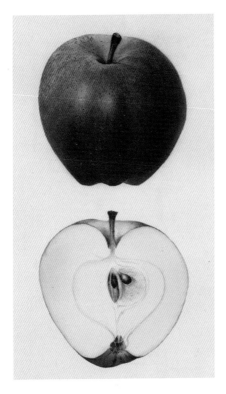

Tompkins King
apple (*Malus domestica*),
Chelan, Washington,
1931
Mary Daisy Arnold
(1873–1955)

Utter of Wisconsin
apple (*Malus
domestica*), Wisconsin
Mary Daisy Arnold
(1873–1955)

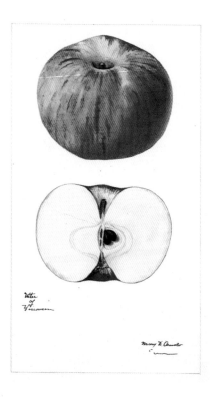

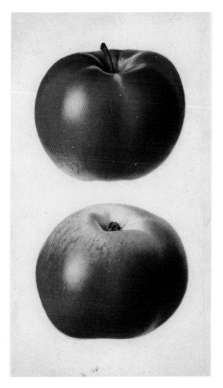

Wagener apple (*Malus domestica*), Ontario, New York, 1921
Royal Charles Steadman
(1875–1964)

Weathly apple (*Malus domestica*), Dane, Wisconsin, 1921
Royal Charles Steadman (1875–1964)

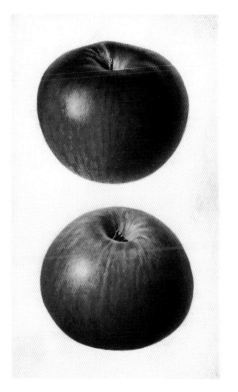

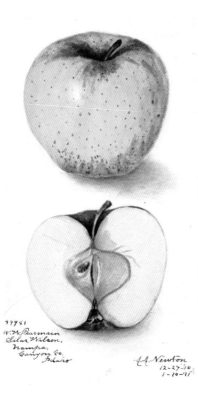

White Pearmain apple
(*Malus domestica*),
Canyon, Idaho, 1911
Amanda Almira Newton
(c. 1860–1943)

44981
W. H. Pearmain
Silas Wilson,
Nampa,
Canyon Co.,
Idaho

A. A. Newton
12-27-10
1-10-11

Whitney apple (*Malus domestica*), Arlington, Virginia, 1933
Royal Charles Steadman (1875–1964)

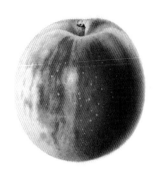

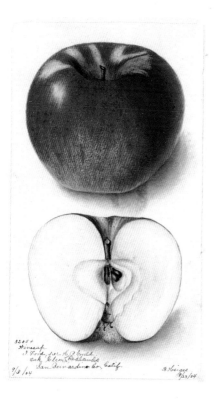

Winesap apple
(*Malus domestica*),
San Bernadino,
California, 1904
Bertha Heiges
(1866–1956)

Winter Banana
apple (*Malus
domestica*), Arlington,
Virginia, 1928
Mary Daisy Arnold
(1873–1955)

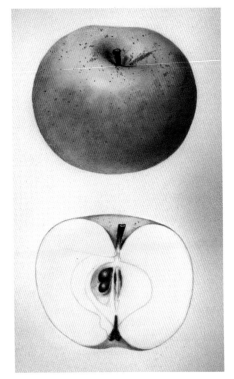

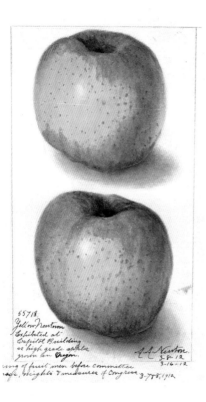

Yellow Newtown apple
(*Malus domestica*),
Oregon, 1912
Amanda Almira Newton
(c. 1860–1943)

55718.
Yellow Newtown
Exhibited at
Capitol Building
as high grade apples
grown in Oregon.
A. A. Newton
3-8-12
...ing of fruit men before committee
...ofs, Weights & measures of Congress 3-778, 1912

Yellow Transparent apple (*Malus domestica*), Kent, Delaware, 1902 Deborah Griscom Passmore (1866–1956)

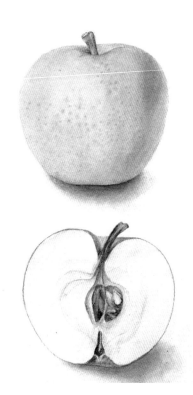

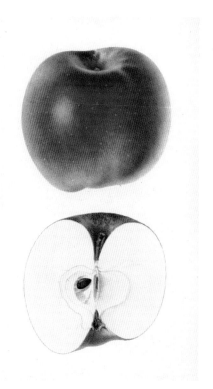

York Imperial apple
(*Malus domestica*),
Arlington, Virginia, 1927
Royal Charles Steadman
(1875–1964)

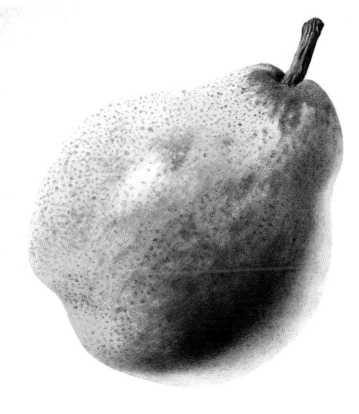

2

PEARS AND OTHER POMES

Pear is the second-most popular of the pome fruits (subfamily Maloideae of the Rose family), and is joined in that subfamily by, of course, apple as well as less familiar fruit kin such as quince, medlar, and hawthorn. A notable characteristic of this subfamily is that the base of the flower fuses with the ovary; in layperson's terms, the resulting fruit has a core. Flesh within the core is derived from the outer wall of the ovary. Beyond the core, the base of the flower morphs into the tasty flesh.

Loquat, another member, is particularly interesting for being subtropical and for bearing flowers in autumn that ripen into fruits in the spring or summer of the following year. In flavor, loquat might be compared to apricot, a fruit from yet another subfamily.

Returning to pears . . . the paltry number of varieties offered in today's markets belies the thousands of varieties that exist. Thousands? That number is not surprising, since forty different varieties were identified as far back as Roman times.

European pears (*Pyrus communis*) got a big push and became very popular in northern Europe in the nineteenth century thanks mostly to two Belgians, Nicolas Hardenport and Jean-Baptiste Van Mons, who began breeding *beurré*—that is, buttery—varieties. Among the best, available today and depicted in the watercolors, was Comice (page 123), described by Ulysses P. Hedrick in his tome *The Pears of New York* in 1921 as "melting, tender, buttery, very juicy; sweet and vinous, aromatic; good to very best." I agree.

One challenge in growing European pears is ripening them to perfection. They ripen from the inside out so must be harvested mature, but not ripe, and then ripened in a cool room. Timing is all. Emerson wrote, "There are only ten minutes in the life of a pear when it is perfect to eat."

Medlar, another pome fruit, is similar in ripening, except when ready to eat the flesh has turned to brown mush—a very delectable brown mush but not one to appeal to the visuals demanded by commercial markets.

Not so for a whole other category of pear, Asian pear (*nashi*), which represents one, or a mix, of four species (*P. pyrifolia, P. ussuriensis, P. bretschneideri,* and *P. pashia*). Asian pears are harvested when fully ripe on the tree, at which point the flesh is sweet and

slightly floral. With each bite, the crisp texture explodes with juice. As with European pears, only a few of the many varieties of Asian pear are available in today's markets.

The Pomological Watercolors highlight the beauty and differences among the varieties of European and Asian pears. Also the visual differences among relatively few, excepting apple, of the other pome fruits. You'd have to grow them yourself to experience the full range of flavors, aromas, and textures of the lesser-known members of this subfamily.

Anjou pear
(*Pyrus communis*),
Washington, DC,
1932
Mary Daisy Arnold
(1873–1955)

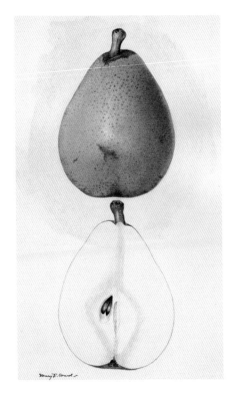

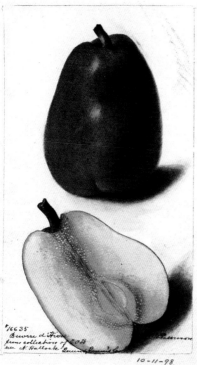

Beurre d'Hiver
pear (*Pyrus communis*),
Queens, New York,
1898
Deborah Griscom
Passmore (1866–1956)

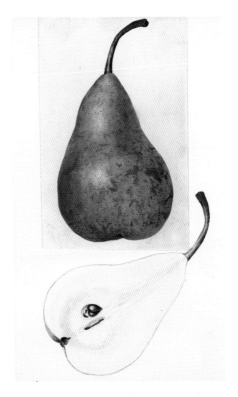

Bosc pear
(*Pyrus communis*),
Van Buren,
Michigan, 1932
Mary Daisy Arnold
(1873–1955)

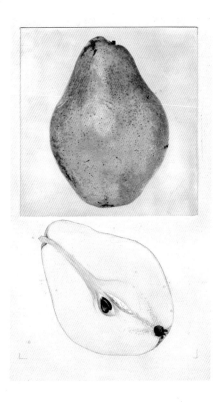

Cobert pear (*Pyrus communis*), Ontario, New York, 1936
Mary Daisy Arnold
(1873–1955)

Dana Honey pear
(*Pyrus communis*), Van
Buren, Michigan, 1932
Mary Daisy Arnold
(1873–1955)

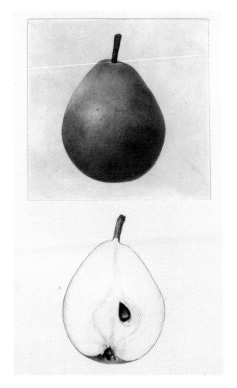

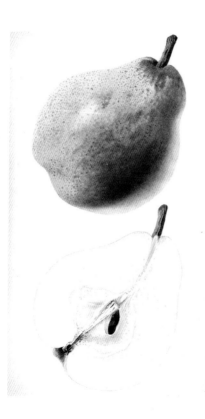

Doyenne du Comice
pear (*Pyrus communis*),
Santa Clara,
California, 1926
Royal Charles Steadman
(1875–1964)

Flemish Beauty pear
(*Pyrus communis*),
Hood River,
Oregon, 1935
L. C. Krieger
(1873–1940)

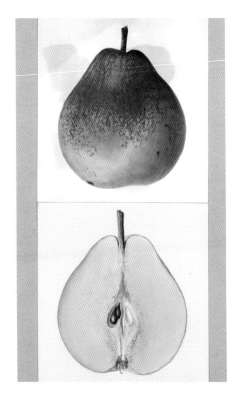

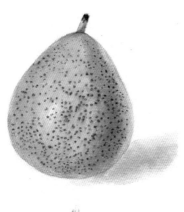

Forella pear (*Pyrus communis*), Santa Clara, California, 1911
Mary Daisy Arnold
(1873–1955)

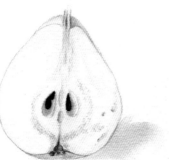

Lucy Duke pear (*Pyrus communis*), Monroe, New York, 1899
Bertha Heiges
(1866–1956)

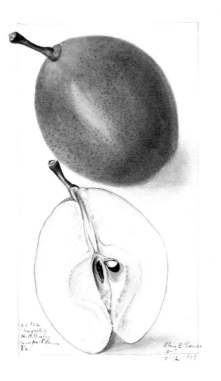

Magnolia pear
(*Pyrus communis*),
Virginia, 1909
Elsie E. Lower
(1882–1971)

Nun's Thigh pear
(*Pyrus communis*)
Mary Daisy Arnold
(1873–1955)

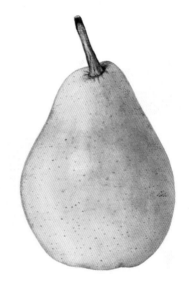

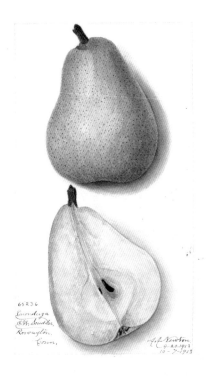

Onondaga pear (*Pyrus communis*), Fairfield, Connecticut, 1913
Amanda Almira Newton
(c. 1860–1943)

Ovid pear (*Pyrus communis*), Ontario, New York, 1937
Mary Daisy Arnold
(1873–1955)

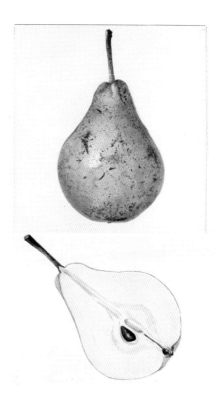

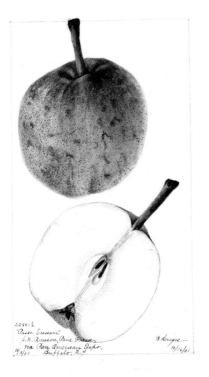

Passe Crassane pear
(*Pyrus communis*),
Erie, New York, 1901
Bertha Heiges
(1866–1956)

Reader pear (*Pyrus communis*), Van Buren, Michigan, 1919
Royal Charles Steadman (1875–1964)

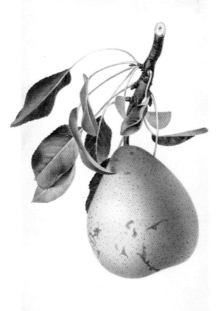

Reader.
Exp. Station.
So. Haven, Mich.

R. C. Steadman
9-12-19.

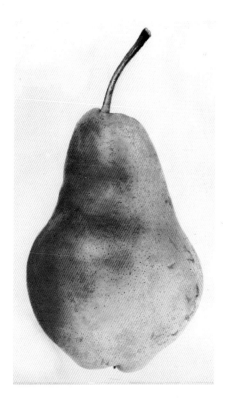

Willard pear (*Pyrus communis*), Ontario, New York, 1936
Mary Daisy Arnold
(1873–1955)

Ussurian pear (*Pyrus ussuriensis*), 1918
Royal Charles
Steadman (1875–1964)

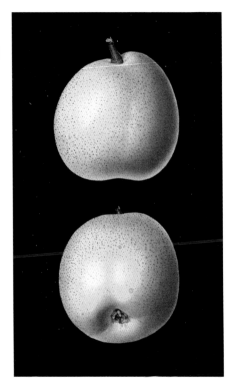

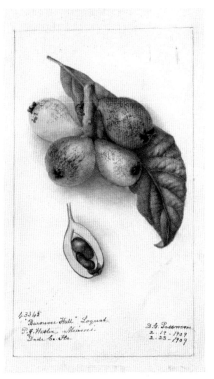

Baronne Hall loquat
(*Eriobotrya japonica*),
Dade, Florida, 1909
Deborah Griscom
Passmore (1866–1956)

4.33.45
"Baronne Hall" Loquat
P.J. Wester. Miami.
Dade Co. Fla.

D.G. Passmore
2.19-1909
2.23-1909

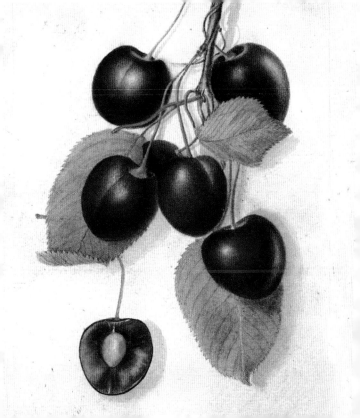

3

STONE FRUITS

"**S**tone fruits," if you've never heard the term, don't sound very appetizing. But it's an apt descriptor if you recall the hard pit of peaches, nectarines, plums, cherries, and apricots, all in the genus *Prunus*.

Like pome fruits, stone fruits are in the Rose family, but a different subfamily. Slice a peach flower up its middle and you'll readily see the difference between this subfamily, Amygdaloideae, and the pome fruit subfamily. In stone fruits, the base of the flower is free from the ovary; it is the outer wall of the ovary that becomes the fruit's flesh and skin. Stone fruits, in contrast to pome fruits, have no core.

Stone fruits trace their roots to China and Western Asia. Imagine hiking in China in the early twentieth century along with USDA plant explorer Frank N. Meyer. There you would, as he did, come upon wild peach trees with the full range of characteristics—red flesh, white flesh, freestone, clingstone—that we know today.

Peach pits were carried to America in the sixteenth century, where they found a welcome reception. Colonists as well as Native Americans were soon cultivating peach orchards. Peaches also forged their own path, especially in the southeast, resulting in wild stands that came to be known as "Tennessee naturals." It wasn't until the nineteenth century that peaches were elevated from a fruit to feed hogs or ferment into brandy to a fruit to be eaten fresh, the result of breeding and selection of better-eating varieties such as Belle of Georgia (page 155), Early Crawford (page 161), and Elberta (page 164).

Hiking farther west with Frank Meyer, where the climate was more inimical to other fruits, we'd happen upon forests of fruiting apricot trees! And even farther west, we'd find trees whose branches were laden with sweet and sour cherries and European plums.

European plums were not the only plums on the block here in America; species and hybrids from East Asia and North America also figure in the mix. By 1915, there were hundreds of native varieties, although not always labeled as such in the watercolors. For instance, Santa Rosa (page 191) is listed as a European plum, but it is actually a hybrid of Asia.

Cherries today have remained truer to their early twentieth-century roots. Many of the varieties depicted in the watercolors are still grown commercially. Like other fruits, they reached and were spread throughout our country as grafted trees and as seedlings.

In 1847, the Lewelling brothers traveled from Iowa to Milwaukie, Oregon, with an oxcart weighed down with three hundred cherry trees. Seth Lewelling also planted cherry seeds, and he named one of his particularly promising trees after his Manchurian orchard foreman, Bing. Bing is the most popular variety of cherry today (page 143).

Blenheim Japanese apricot (*Prunus armeniaca*), Placer, California, 1902
Deborah Griscom Passmore (1866–1956)

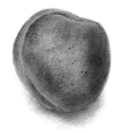

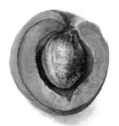

24995
Blenheim
J. J. Clark
Loomis, Placer Co. Calif.

D.G.Passmore
7.3.1902

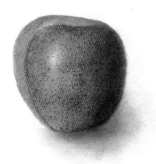

Moorpark Japanese
apricot (*Prunus
armeniaca*), Kaufman,
Texas, 1908
Deborah Griscom
Passmore (1866–1956)

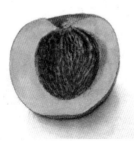

Royal Japanese apricot
(*Prunus armeniaca*),
Yolo, California, 1909
Deborah Griscom
Passmore (1866–1956)

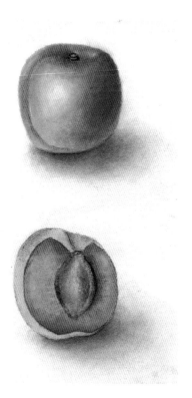

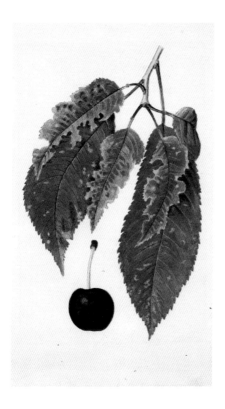

Bing cherry (*Prunus avium*), Chelan, Washington, 1935
James Marion Shull
(1872–1948)

Early Morello
cherry (*Prunus cerasus*),
Ontario, New York,
1916
Mary Daisy Arnold
(1873–1955)

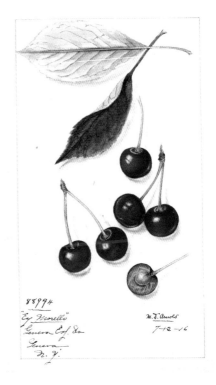

88994
"Ey Morello"
Geneva Ex. Sta
Geneva
N. Y.

M. D. Arnold
7-12-16

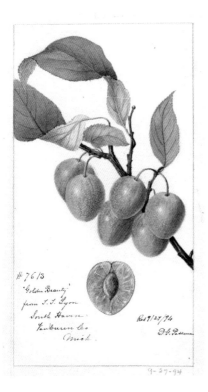

Golden Beauty cherry
(*Prunus avium*), Van
Buren, Michigan, 1894
Deborah Griscom
Passmore (1866–1956)

#7613
"Golden Beauty"
from T. T. Lyon
South Haven.
Vanburen Co
Mich.

Recd 9/27/94
D.G. Passmore

9-27-94

Lambert cherry
(*Prunus avium*),
Hood River,
Oregon, 1907
Deborah Griscom
Passmore (1866–1956)

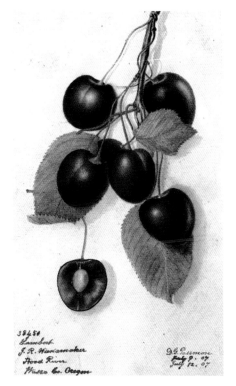

38450
Lambert
J. R. Wanamaker
Hood River
Wasco Co. Oregon

D.G. Passmore
July 9. 07
July 12. 07

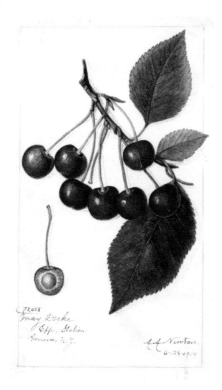

May Duke cherry
(*Prunus avium* × *P. cerasus*), Ontario,
New York, 1914
Amanda Almira Newton
(c. 1860–1943)

Montmorency
cherry (*Prunus cerasus*),
Ontario, New York,
1912
Mary Daisy Arnold
(1873–1955)

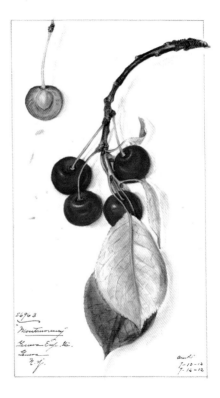

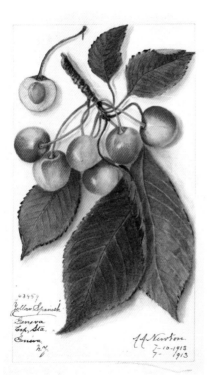

Yellow Spanish cherry
(*Prunus avium*),
Ontario, New York, 1913
Amanda Almira Newton
(c. 1860–1943)

Quetta nectarine
(*Prunus persica*), 1935
James Marion Shull
(1872–1948)

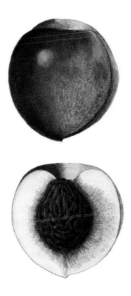

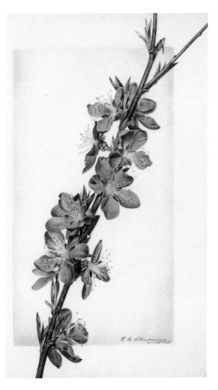

Peach blossoms (*Prunus persica*), Arlington, Virginia, 1924
Royal Charles Steadman
(1875–1964)

Arctic peach (*Prunus persica*), Iowa, 1908
Ellen Isham Schutt
(1873–1955)

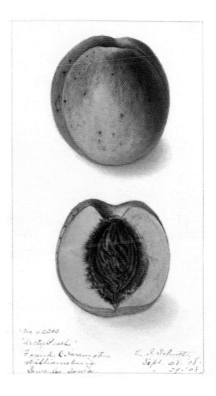

No 42300.
"Arctic Peach"
Frank O. Harrington E. I. Schutt.
Williamsburg Sept 28.'08
Swales Iowa " 29.'08.

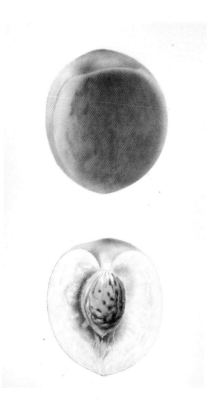

Babcock peach (*Prunus
persica*), San Bernardino,
California, 1932
Royal Charles Steadman
(1875–1964)

153

Banner Free peach
(*Prunus persica*),
Arlington,
Virginia, 1910
Elsie E. Lower
(1882–1971)

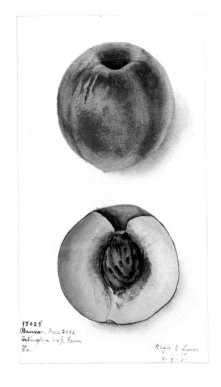

Belle of Georgia
peach (*Prunus persica*),
Morgan, West
Virginia, 1911
James Marion Shull
(1872–1948)

Bloomington peach
(*Prunus persica*),
Washington,
Utah, 1914
Mary Daisy Arnold
(1873–1955)

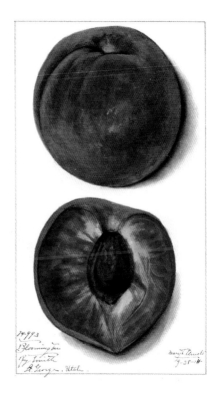

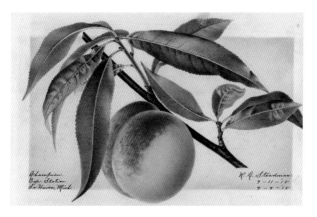

Champion peach (*Prunus persica*), Georgia, 1918
Royal Charles Steadman (1875–1964)

Comal Cling peach
(*Prunus persica*),
Comal, Texas, 1898
Deborah Griscom
Passmore (1866–1956)

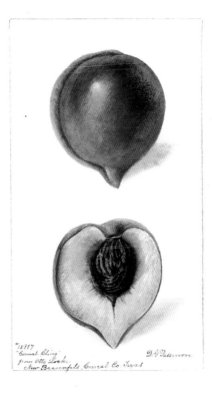

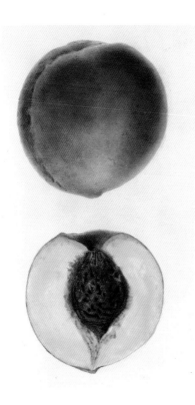

Crawford Late peach
(*Prunus persica*), Prince
George's, Maryland, 1936
Mary Daisy Arnold
(1873–1955)

Dalmont Favorite
peach (*Prunus persica*),
Texas, 1912
Ellen Isham Schutt
(1873–1955)

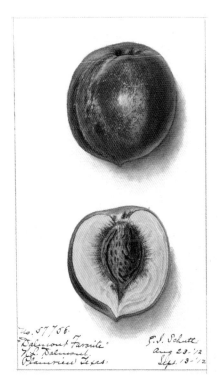

No. 57,756.
"Dalmont Favorite"
of Dalmont
Plainview Texas.

E. I. Schutt
Aug 23-'12
Sept. 13-'12

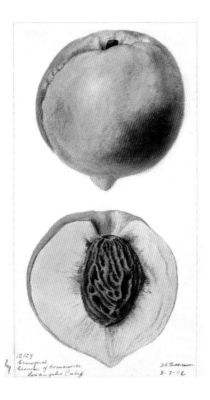

12129
Crawford
Chamber of Commerce
Los Angeles Calif.

H. Passmore
8-7-96

Early Crawford peach
(*Prunus persica*), Los
Angeles, California, 1896
Deborah Griscom
Passmore (1866–1956)

161

Early Halehaven peach
(*Prunus persica*), Prince
George's, Maryland,
1942
Mary Daisy Arnold
(1873–1955)

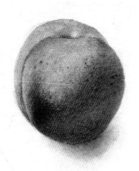

Early Rivers peach
(*Prunus persica*), Sussex,
Delaware, 1902
Deborah Griscom
Passmore (1866–1956)

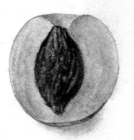

163

Elberta peach (*Prunus persica*), Peach, Georgia, 1926
Royal Charles Steadman (1875–1964)

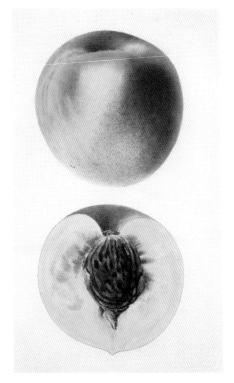

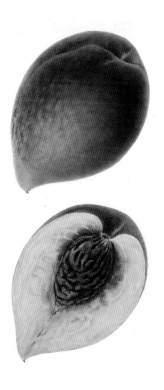

Evans Specialty peach
(*Prunus persica*), Georgia
Royal Charles Steadman
(1875–1964)

Frank peach (*Prunus persica*), Limestone, Texas, 1912
Amanda Almira Newton (c. 1860–1943)

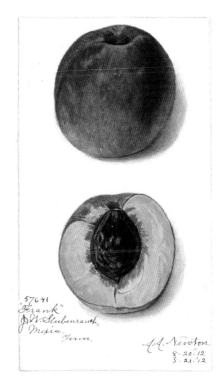

57641
"Frank"
J.W. Steubenrauch,
Mexia,
Tenn.

A.A. Newton.
8-20-12
8-21-12

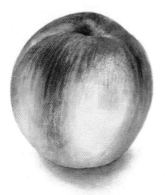

General Lee peach
(*Prunus persica*), Macon,
Georgia, 1902
Deborah Griscom
Passmore (1866–1956)

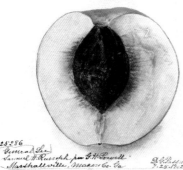

25.286
General Lee
Samuel H. Rumph per G. H. Powell
Marshallville, Macon Co. Ga
D. G. Passmore
7.25.1902

Georgia Cling peach
(*Prunus persica*),
Arlington,
Virginia, 1911
Mary Daisy Arnold
(1873–1955)

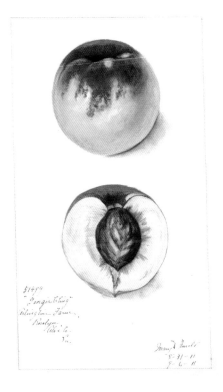

Hale Haven peach
(*Prunus persica*),
Prince George's,
Maryland, 1940
Mary Daisy Arnold
(1873–1955)

Halehaven

Highland Beauty
peach (*Prunus persica*),
Cloverdale, Michigan,
1907
Ellen Isham Schutt
(1873–1955)

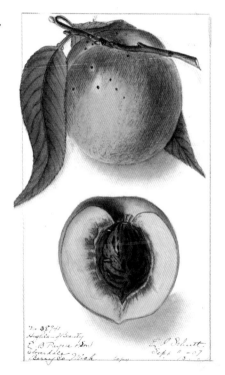

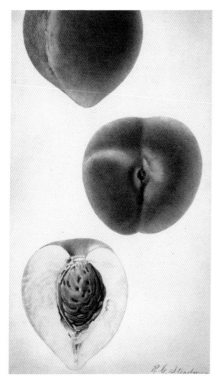

Hiley peach
(*Prunus persica*), Peach,
Georgia, 1925
Royal Charles Steadman
(1875–1964)

Imp. Crawford
peach (*Prunus persica*),
Sonoma, California,
1917
Royal Charles
Steadman (1875–1964)

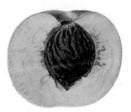

No. 93481
"Imp. Crawford"
Cash Nurseries
Sebastopol, Calif.

R. C. Steadman
8-31-'17
9-6-'17

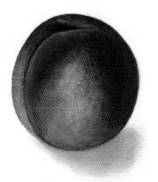

Improved Bailey peach
(*Prunus persica*), Linn,
Iowa, 1908
Ellen Isham Schutt
(1873–1955)

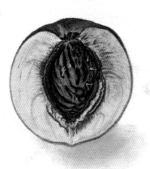

J. H. Hale peach
(*Prunus persica*),
Hartford,
Connecticut, 1913
Ellen Isham Schutt
(1873–1955)

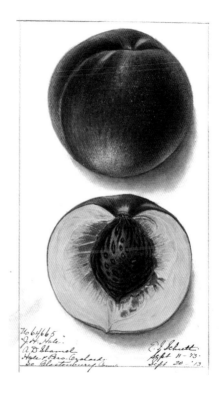

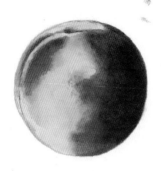

June Elberta peach
(*Prunus persica*),
Prince George's,
Maryland, 1940
Mary Daisy Arnold
(1873–1955)

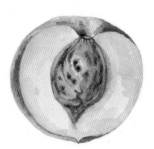

Late Admiral
peach (*Prunus persica*),
Arlington, Virginia,
1910
Mary Daisy Arnold
(1873–1955)

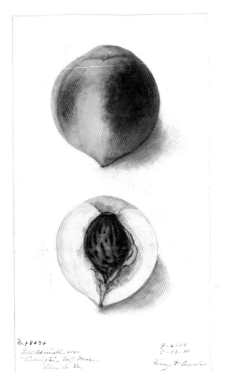

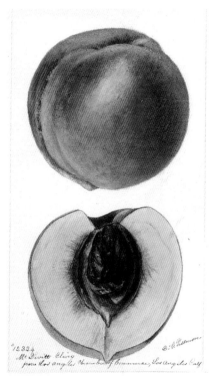

"12324
Mc Devitt Cling
from Los Angeles Chamber of Commerce, Los Angeles Calif.

D. G. Passmore.

McDevitt Cling peach
(*Prunus persica*), Los
Angeles, California, 1896
Deborah Griscom
Passmore (1866–1956)

Miller peach (*Prunus persica*), Arlington, Virginia, 1910
Elsie E. Lower
(1882–1971)

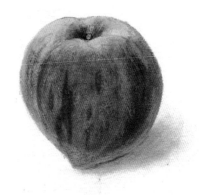

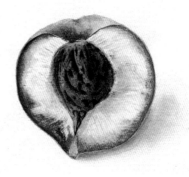

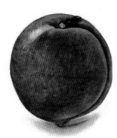

Neva Myss peach
(*Prunus persica*),
Moore, North
Carolina, 1916
Mary Daisy Arnold
(1873–1955)

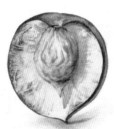

885-5-9
"Neva Myss"
H. G. Phillips
Southern Pines
N. C.

mary D. Arnold
5-31-16
6-1-16

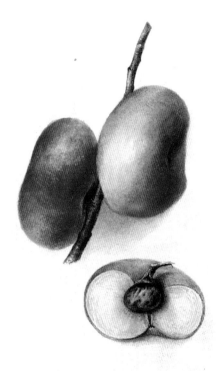

Pento peach (*Prunus persica*), Hillsborough, Florida, 1902
Deborah Griscom Passmore (1866–1956)

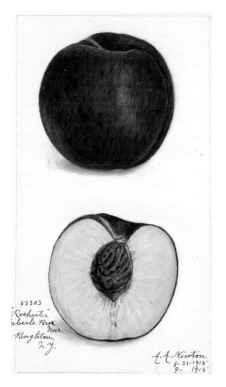

Rochester peach
(*Prunus persica*),
Monroe, New York, 1915
Amanda Almira Newton
(c. 1860–1943)

83303
"Rochester"
Eberle Bros.
Brighton,
N.Y.

A. A. Newton.
8-31-1915
9- 1915

181

Slappy peach (*Prunus persica*), Crawford, Arkansas, 1906
Deborah Griscom Passmore (1866–1956)

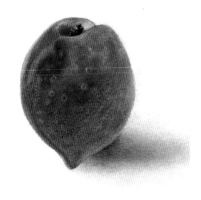

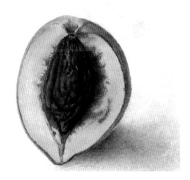

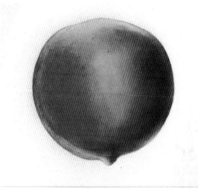

Stanford peach (*Prunus persica*), Santa Clara, California, 1938
Mary Daisy Arnold
(1873–1955)

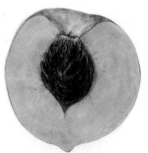

Victor peach (*Prunus persica)*, Arlington, Virginia, 1910
Deborah Griscom Passmore (1866–1956)

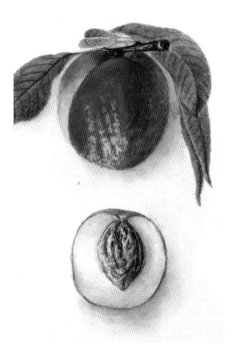

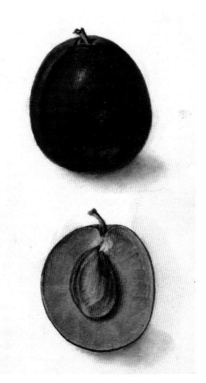

Ascension plum (*Prunus domestica*), Union, Oregon, 1900
Deborah Griscom Passmore (1866–1956)

Cherry plum
(*Prunus cerasifera* var.
divaricata)

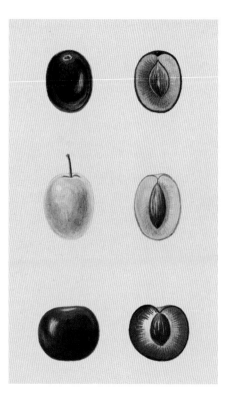

Damson plum (*Prunus domestica* subsp. *insititia*), Washington, DC, 1930
Royal Charles Steadman (1875–1964)

187

Formosa plum (*Prunus salicina* hybrid), Prince George's, Maryland, 1940
Mary Daisy Arnold
(1873 1955)

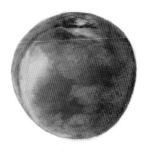

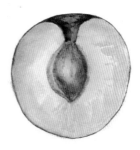

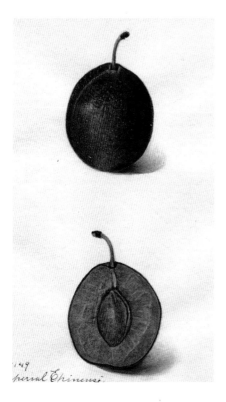

Imperial Epineuse plum
(*Prunus domestica*),
Ontario, New York, 1916
Amanda Almira Newton
(c. 1860–1943)

Methley plum (*Prunus salicina*), Sacramento, California, 1915
Harriet Thompson

Santa Rosa plum
(complex hybrid
involving *Prunus
salicina*), Santa Clara,
California, 1935
James Marion Shull
(1872–1948)

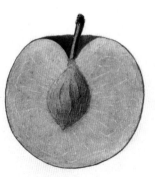

Shiro plum
(*Prunus salicina*),
Prince George's,
Maryland, 1912
Ellen Isham Schutt
(1873–1955)

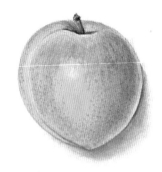

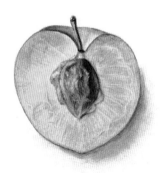

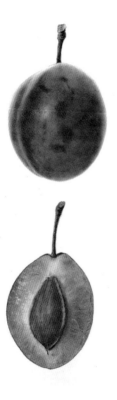

Stanley plum (*Prunus domestica*), Prince George's, Maryland, 1939
Mary Daisy Arnold (1873–1955)

Steptoe plum (*Prunus domestica*), Whitman, Washington, 1894
Deborah Griscom Passmore (1866–1956)

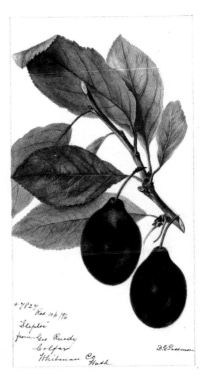

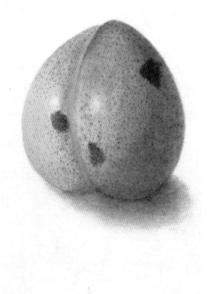

Wickson plum
(*Prunus salicina*),
New York, 1905
Ellen Isham Schutt
(1873–1955)

Yamhill plum (*Prunus domestica*), Yamhill, Oregon, 1898
Deborah Griscom Passmore (1866–1956)

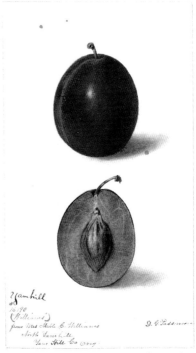

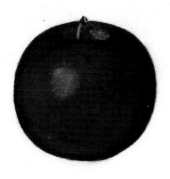

Yellow Egg
plum (*Prunus
domestica*), 1939
Mary Daisy Arnold
(1873–1955)

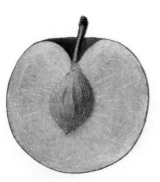

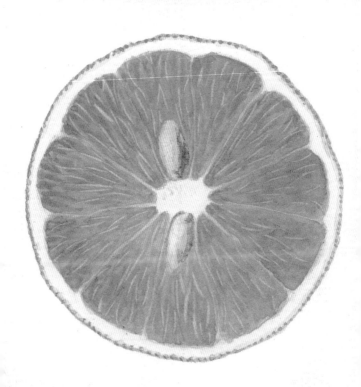

4

CITRUS

Citrus—such a diverse genus. Its members range from super-tart sour oranges to tart-fleshed, sweet-skinned kumquats to honey-sweet-fleshed Murcott mandarins (tangerines). And, in size, from golf-ball kumquats to volleyball pomelos. Despite this diversity, all citrus sprang eons ago from common ancestors in the Himalayan foothills. Mandarin, citron, and pomelo, acknowledged as the three ancestral species, spread about seven million years ago with the changing climate of the Miocene period through Asia.

The earliest written reference to citrus is found in the *Tribute to Yu*; Yu being the Chinese emperor in about 2200 BCE. Citrus eventually traveled west into Europe along ancient trade routes, and then to the New World, initially as seeds brought to Haiti with Columbus's second voyage. Citrus was first planted in Florida in 1565.

During the travels of this genus, it continued morphing into various forms, leading to a number of varieties. Some of these varieties, such as the Marsh grapefruit (page 207) and the Bearss lime began life as chance seedlings. Others were selected progeny from deliberate breeding programs, the first of which began in the United States in 1893, about the time of the first Pomological Watercolors.

Still other varieties originated as sports—that is, as random bud mutations that gave rise to branches bearing better fruits. Such was the origin of the Washington Navel orange (page 221) in the late nineteenth century. All trees clonally propagated from that branch would be identical, unless, of course, a bud on that tree mutated and grew into a branch. One such mutation yielded the Cara Cara orange, a sport of Washington Navel discovered in Venezuela in 1976.

Occasionally, owing to mutation or grafting, the tip of the growing point of a citrus plant is home to two genetically different cells. The result: a chimera. Much like the chimera of mythology, except this one is real, and a few are among the watercolors (page 206).

More recently, new relations have been invited into the citrus genus. Kumquat was, until recently, *Fortunella japonica*; now it's *Citrus japonica* (page 211). Hardy orange was originally *Poncirus trifoliata*; now it's *Citrus trifoliata* (page 209).

Members of the citrus genus, including the new members, readily interbreed, and have given rise to interesting fruits whose

euphonious common names reflect their parentage. So we have tangor, a hybrid of tangerine and orange (page 225); limequat, the offspring of lime and kumquat; and, more complex, citrange-quat, whose parents are lime and citrange. What's a citrange? A hybrid of orange and hardy orange, the latter of which is cold-hardy enough to brave winters outdoors, as in front of my barn here in upstate New York's Hudson Valley. Unfortunately, its small "oranges" are hardly edible (pages 203 and 204).

Calamondin (*Citrus madurensis*), Dade, Florida, 1909
Deborah Griscom Passmore (1866–1956)

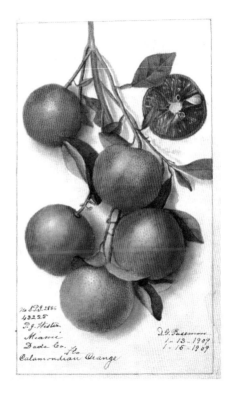

No S.P.I. 2886
43225
P.J. Wester
Miami
Dade Co. Fla
Calamondian Orange

D.G. Passmore
1-13-1909
1-16-1909

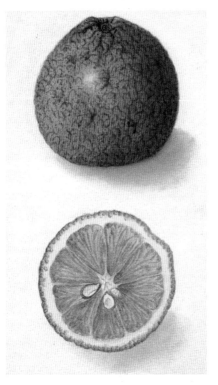

Citrange (*Citrus webberi*
× *Citroncirus* spp.), 1909
Ellen Isham Schutt
(1873–1955)

Willett citrange (*Citrus webberi* × *Citroncirus* spp.), Florida, 1908
Elsie E. Lower
(1882–1971)

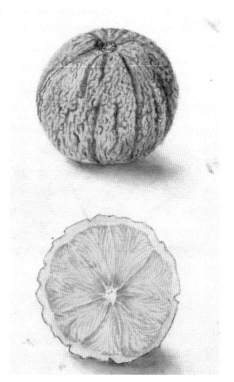

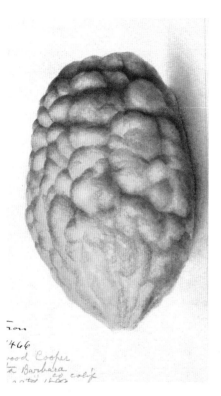

Citron (*Citrus medica*), Santa Barbara, California, 1899

'466
ood Cooper
a Barbara co calif

Chimera grapefruit
(*Citrus paradisi*),
Baker, Florida, 1913
Ellen Isham Schutt
(1873–1955)

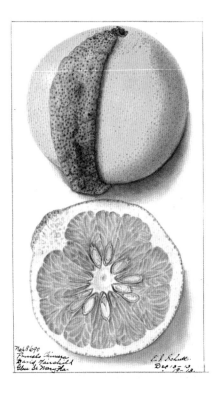

No. 68690
Pomelo Chimera
Davis Fairchild
Glen St Mary, Fla.

E. I. Schutt.
Dec 19-13.

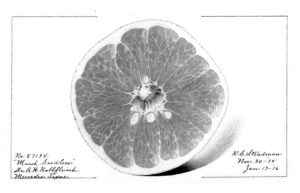

No: 87134.
"Marsh Seedless".
Mr. A.H. Kallfleisch.
Mercedes, Texas.

R. C. Steadman
Nov. 30–15
Jan. 17–16

Marsh Seedless grapefruit (*Citrus paradisi*), Hidalgo, Texas, 1916
Royal Charles Steadman (1875–1964)

Silver Cluster
grapefruit (*Citrus
paradisi*), Polk, Florida
Deborah Griscom
Passmore (1866–1956)

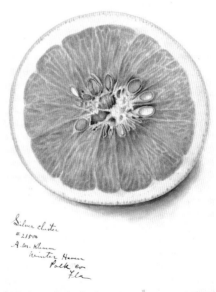

Silver cluster
#21500
A.M. Klemm
Winter Haven
Polk co.
Fla

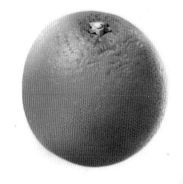

Hardy orange
(*Citrus trifoliata*),
California, 1931
Royal Charles Steadman
(1875–1964)

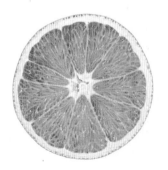

Key lime (*Citrus ×
aurantiifolia*), Lake,
Florida, 1909
Elsie E. Lower
(1882–1971)

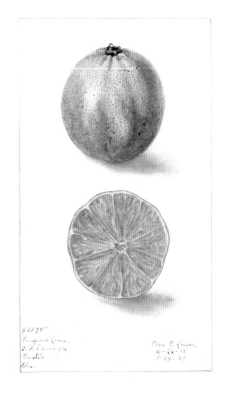

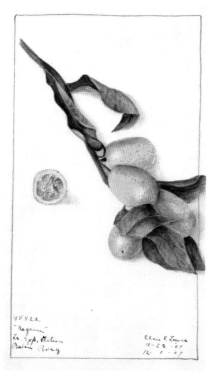

Nagami kumquat (*Citrus japonica*), Louisiana, 1909
Elsie E. Lower
(1882–1971)

45822
"nagami"
La. Exp. Station
Baton Roug

Elsie E Lower
11-22-09
12-1-09

American Wonder
lemon (*Citrus
limon*), Norfolk,
Massachusetts, 1910
Ellen Isham Schutt
(1873–1955)

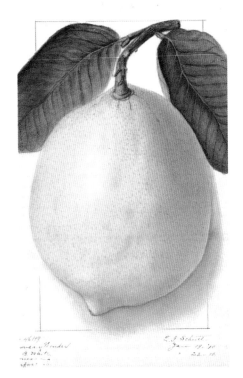

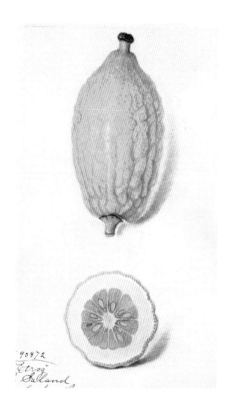

Etrog lemon (*Citrus limon*), Greece, 1916
Amanda Almira Newton
(c. 1860–1943)

90872
Etrog
Poland

Meyer lemon (*Citrus limon*), Butte, California, 1926
Royal Charles Steadman (1875–1964)

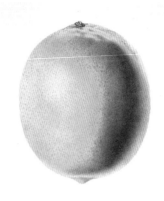

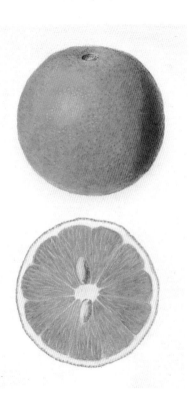

Jaffa orange (*Citrus sinensis*), Orange, Florida, 1937
James Marion Shull
(1872–1948)

Magnum Bonum orange (*Citrus sinensis*), Lake, Florida, 1894
Deborah Griscom Passmore (1866–1956)

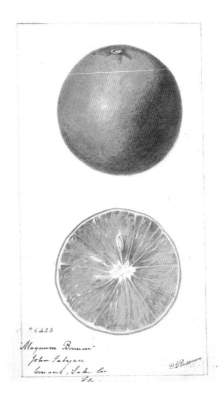

6423

Magnum Bonum
John Fabyan
Conant, Lake Co.
Fla.

D.G.Passmore

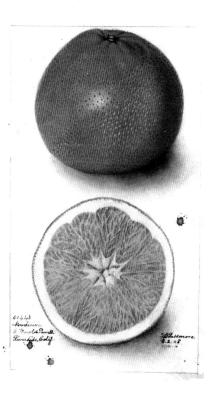

Navelencia orange
(*Citrus sinensis*),
Riverside,
California, 1908
Deborah Griscom
Passmore (1866–1956)

Pineapple orange
(*Citrus sinensis*),
Brevard, Florida, 1936
Mary Daisy Arnold
(1873–1955)

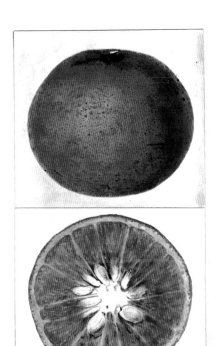

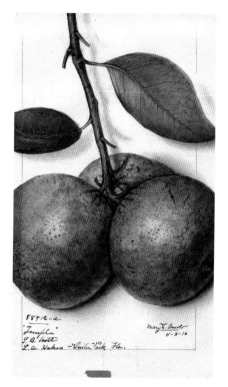

Temple orange (*Citrus sinensis* × *C. reticulata*), Orange, Florida, 1916
Mary Daisy Arnold
(1873–1955)

Valencia orange (*Citrus sinensis*), Riverside, California, 1913
Ellen Isham Schutt
(1873–1955)

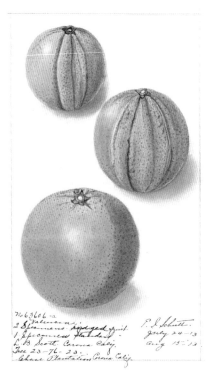

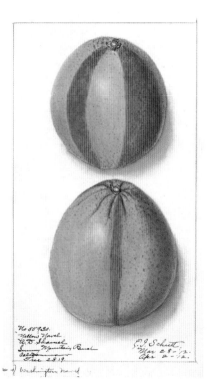

Washington Navel
orange (*Citrus sinensis*),
California, 1912
Ellen Isham Schutt
(1873–1955)

No 55930.
"Yellow Navel
G. D. Ikemed
Mountain Ranch
California
Tree 2819

E. J. Schutt.
Mar 28-12.
Apr 2-12.

= Washington Navel

Schang Hybrid pomelo
(*Citrus grandis*),
Baldwin, Alabama, 1931
Mary Daisy Arnold
(1873–1955)

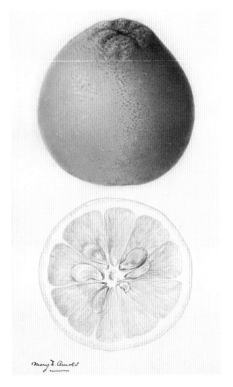

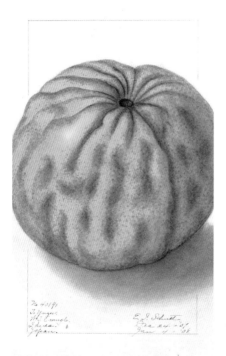

To Yuzu pomelo
(*Citrus junos*, a hybrid of
Citrus cavaleriei and *C.
reticulata*), Japan, 1908
Ellen Isham Schutt
(1873–1955)

Francis Heiney
tangerine (*Citrus
reticulata*), Imperial,
California, 1918
Royal Charles
Steadman (1875–1964)

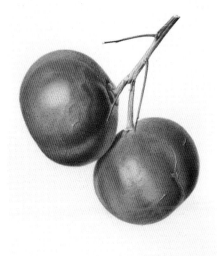

No. 96508.
Francis Heiney.
Brawley Imperial Valley.
California.

R.C. Steadman.
12-21-18
12-18-18

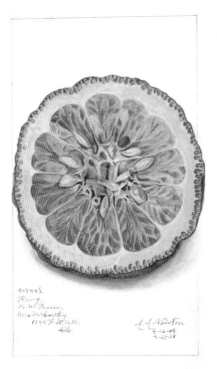

Tangor (*Citrus nobilis*),
Washington, DC, 1908
Amanda Almira Newton
(c. 1860–1943)

408 44½
King
illegible handwriting
mrs McCarthy
1345 F St N.W.
illegible

A A Newton
3-16-08
4-23-08

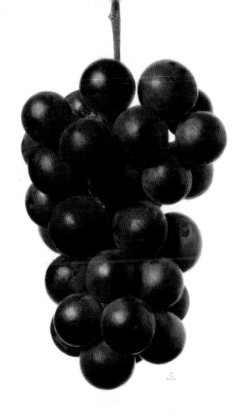

5

BERRIES

For me, berries represent the essence of summer, with strawberries, currants, gooseberries, and raspberries ripening one after another as the season rolls on. But what is a berry? Botanically, a berry is a soft fruit developing from the ovary of a single flower.

Most berries are as fleeting as summer. When soft, sweet, and fully ripe, they're hardly able to travel much farther than arm's length from plant to mouth. This makes the freshness of the cloudberry and the mulberries in their illustrations (pages 234 and 248) all the more remarkable. The cloudberries traveled all the way from Cape Breton Island, Canada, and the mulberries from Collin, Texas, to the desks of the artists.

Not all of the illustrations within this chapter are of berries, at least not in the botanical sense. This chapter's grouping bows to common usage to include any fruit with "berry" in its name. And more. For the record, nonberries here would include black-

berry (pages 230–32), cloudberry, raspberry (pages 249–53), and strawberry (pages 254–62), which, botanically, are aggregate fruits, each derived from a flower with multiple ovaries. Also, mulberry, a multiple fruit formed from multiple ovaries, each with its own flower. And juneberry (page 247), a pome fruit kin to apple and pear. At first blush, juneberry is a dead ringer for blueberry, to which its flavor has been compared. Juneberries do not, in fact, taste at all like blueberries—they have the sweetness and richness of sweet cherry, with a hint of almond.

To round out the vagaries of this list are grapes (pages 238–46), which are true botanical berries, and bananas, which, although true berries, are so far from the popular conception of berries that they find a home in the next chapter.

Berries in the wild have been enjoyed by humans for thousands of years, but their cultivation is more recent. At the time of the earlier watercolors, methods of cultivation and many new varieties had only recently been developed.

Noteworthy are the seven illustrations of blueberries among all the Pomological Watercolors (page 233). Although this native American fruit was enjoyed for centuries by Native Americans and then by European settlers, harvest and marketing of the fruit was restricted to locales where the plants grew wild. More widespread cultivation began in the early twentieth century when USDA scientist Frank Coville and cranberry grower Elizabeth White collaborated to develop better varieties and elucidate the

unique soil requirements of these plants. More than half a century passed before blueberries, with scores of varieties, would become year-round offerings on market shelves throughout this country, and beyond.

Agawam blackberry
(*Rubus* subg. *Rubus*
Watson), Ontario,
New York, 1912
Ellen Isham Schutt
(1873–1955)

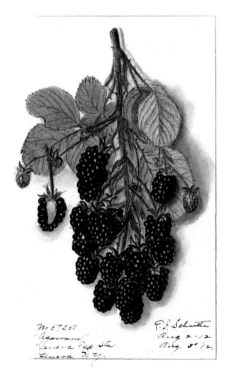

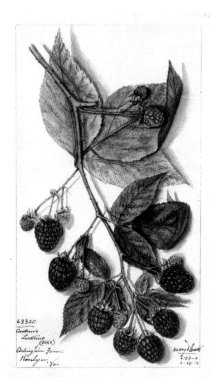

Andrews blackberry
(*Rubus* subg. *Rubus*
Watson), Arlington,
Virginia, 1913
Mary Daisy Arnold
(1873–1955)

Garee blackberry
(*Rubus* subg. *Rubus*
Watson), Arlington,
Virginia, 1916
Royal Charles
Steadman (1875–1964)

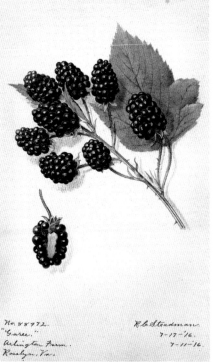

No. 88972.
"Garee."
Arlington Farm.
Rosslyn, Va.

R. C. Steadman.
7-17-'16.
7-11-'16.

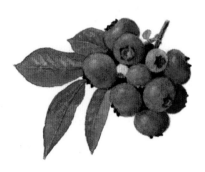

Weymouth blueberry
(*Vaccinium corymbosum*),
New Jersey, 1940
James Marion Shull
(1872–1948)

Cloudberry (*Rubus chamaemorus*), Ferguson Lake, Cape Breton Island, Canada, 1907
Ellen Isham Schutt
(1873–1955)

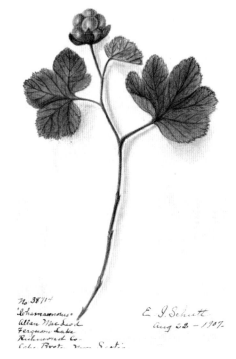

No. 38714
"chamaemorus"
Allan MacLeod
Ferguson Lake
Richmond Co.
Cape Breton, Nova Scotia

E. J. Schutt.
Aug 22 – 1907.

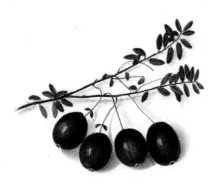

Metallic Bell
cranberry (*Vaccinium
macrocarpon*),
Burlington, New
Jersey, 1913
Amanda Almira Newton
(c. 1860–1943)

45262
Metallic Bell
H.B. Schemmell
Pemberton, N.J.

J.A. Newton.
9-26-1913
11-11-1913

235

Fay red currant (*Ribes* spp.), Montgomery, Maryland, 1916 Royal Charles Steadman (1875–1964)

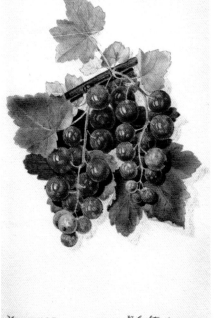

No. 88855.
"Fay."
Dr. Shoemaker.
Takoma Park. Md

R. C. Steadman.
6-26-'16.
6-23-'16

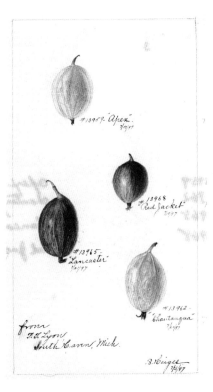

#13959 "Apex"
7/7/97

#13968
"Red Jacket"
7/97

#13965
"Lancaster"
7/2/97

#13962
"Chautauqua"
7/97

from
T. T. Lyon
South Haven, Mich.

B. Heiges
7/7/97

Gooseberry (*Ribes* spp.),
South Haven,
Michigan, 1897
Bertha Heiges
(1866–1956)

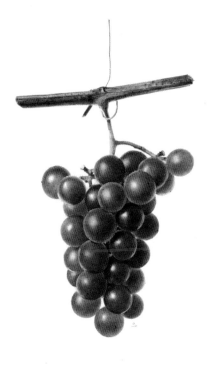

Arkansas grape
(*Vitis* sp.), 1933
James Marion Shull
(1872–1948)

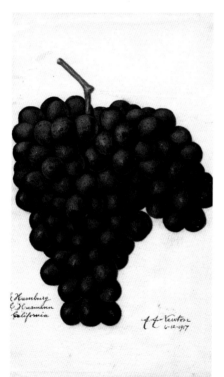

Black Hamburg grape
(*Vitis* sp.), Napa,
California, 1917
Amanda Almira Newton
(c. 1860–1943)

Concord grape
(*Vitis* sp.), 1934
Royal Charles
Steadman (1875–1964)

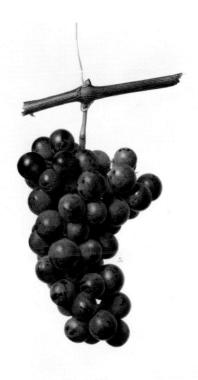

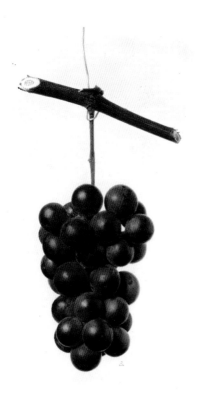

Marsala grape
(*Vitis* sp.), 1933
Royal Charles Steadman
(1875–1964)

Mish grape (*Vitis* sp.),
Perquimans, North
Carolina
Amanda Almira
Newton (c. 1860–1943)

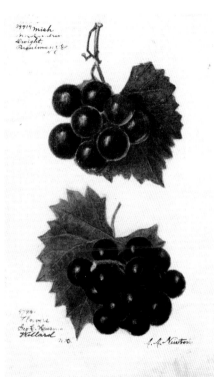

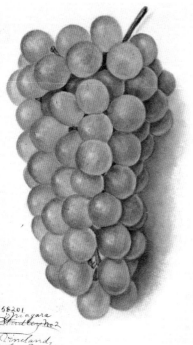

Niagara grape
(*Vitis* sp.), Cumberland,
New Jersey, 1912
Amanda Almira Newton
(c. 1860–1943)

58201
Niagara
Studley No 2
Vineland,
Exp. Vineyard
Vineland N.J.

A.A.Newton

243

Scuppernong grape
(*Vitis rotundifolia*),
Beaufort, South
Carolina, 1906
Amanda Almira
Newton (c. 1860–1943)

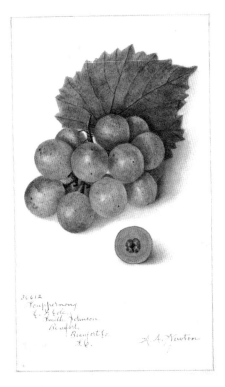

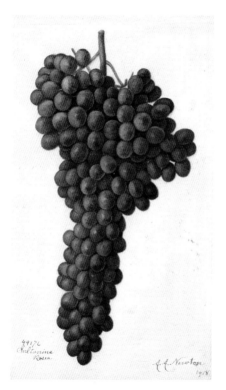

Sultanina Rosea grape
(*Vitis* sp.), 1918
Amanda Almira Newton
(c. 1860–1943)

Wapaunka grape
(*Vitis* sp.)

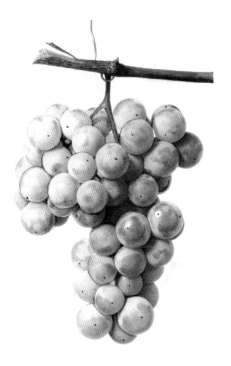

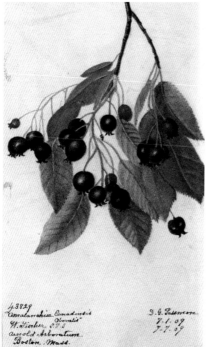

Eastern shadbush juneberry (*Amelanchier canadensis* var. *obovalis*), Suffolk, Massachusetts, 1909
Deborah Griscom Passmore (1866–1956)

4.3829
"Amalanchier Canadensis
obovalis"
W. Fischer, 528
arnold Arboretum.
Boston. Mass.
June berry Spring

D. G. Passmore.
7-1-09
7-7-09

Travis mulberry
(*Morus rubra*), Collin,
Texas, 1908
Deborah Griscom
Passmore (1866–1956)

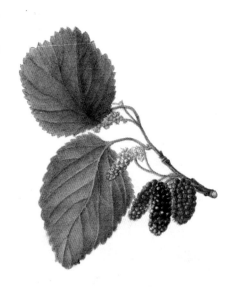

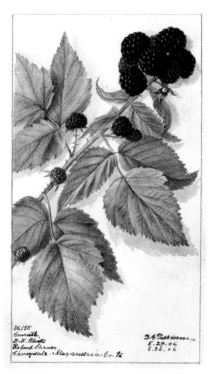

36/55
Conrath
F.W. White
Robert Shrus
Cherrydale · Alexandria Co. Va

D.G. Passmore
5.29.06
6.30.06

Conrath black raspberry
(*Rubus occidentalis*),
Cherrydale, Arlington,
Virginia, 1906
Deborah Griscom
Passmore (1866–1956)

Doolittle black raspberry (*Rubus occidentalis*), Juniata, Pennsylvania, 1891
Frank Muller

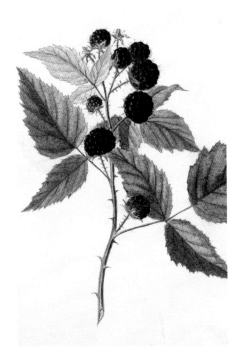

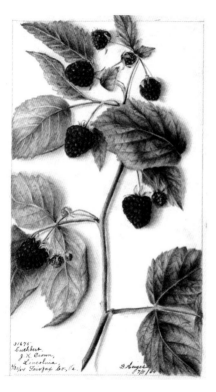

Cuthbert red raspberry
(*Rubus idaeus*),
Fairfax, Virginia, 1904
Bertha Heiges
(1866–1956)

Eaton red raspberry
(*Rubus idaeus*),
Ingham, Michigan,
1906
Ellen Isham Schutt
(1873–1955)

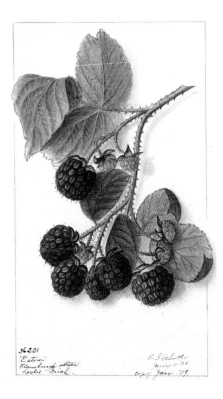

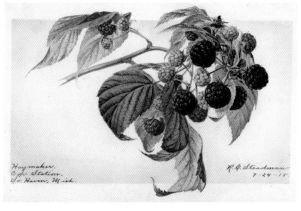

Haymaker purple raspberry (*Rubus* × *neglectus*), Van Buren, Michigan, 1918
Royal Charles Steadman (1875–1964)

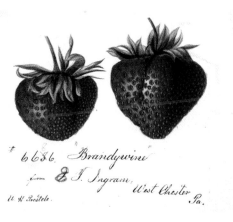

Brandywine strawberry (*Fragaria* sp.), West Chester, Pennsylvania
William Henry Prestele (1838–1895)

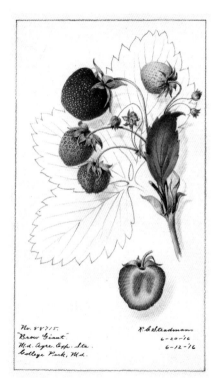

Brow Giant strawberry
(*Fragaria* sp.), Prince
George's, Maryland, 1916
Royal Charles Steadman
(1875–1964)

No. 88715.
"Brow Giant."
Md. Agr. Exp. Sta.
College Park, Md.

R.C. Steadman
6-20-'16
6-12-'16

Dayton strawberry
(*Fragaria* sp.),
Prince George's,
Maryland, 1909
Deborah Griscom
Passmore (1866–1956)

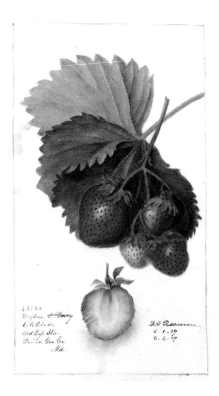

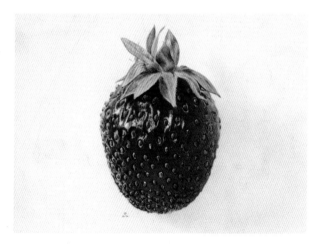

Fairfax strawberry (*Fragaria* sp.)

Kirkwood strawberry (*Fragaria* sp.), Orange, New York, 1891
Frank Muller

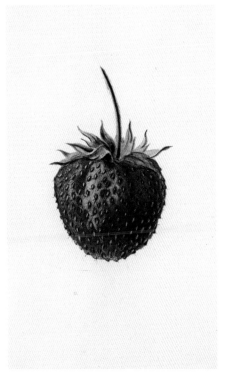

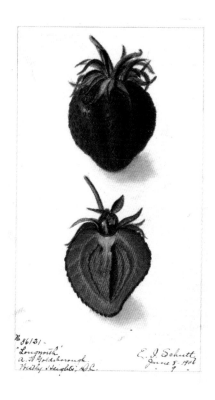

No 36131 —
"Longworth"
A. A. Goldsborough
Washington Heights, D.C.

E. J. Schutt
June 8. 1906
9.

Longworth strawberry
(*Fragaria* sp.),
Washington, DC, 1906
Ellen Isham Schutt
(1873–1955)

M. Crawford strawberry (*Fragaria* sp.), Summit, Ohio, 1911
Ellen Isham Schutt (1873–1955)

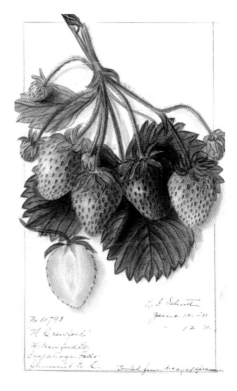

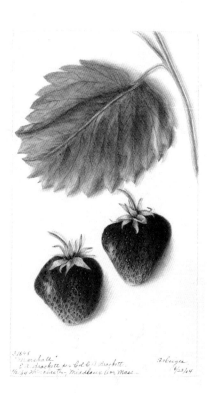

Marshall strawberry
(*Fragaria* sp.),
Middlesex,
Massachusetts, 1904
Bertha Heiges
(1866–1956)

261

Nanticoke strawberry
(*Fragaria* sp.),
Prince George's,
Maryland, 1912
Mary Daisy Arnold
(1873–1955)

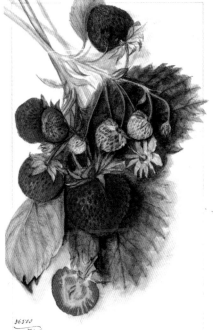

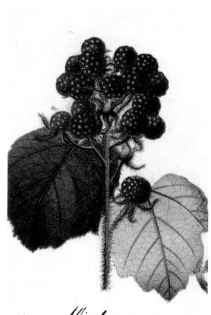

Wineberry (*Rubus phoenicolasius*), York, Pennsylvania, 1894
William Henry Prestele
(1838–1895)

6769
Wineberry
from Prof. S. B. Heiges
York
York Co. Pa.

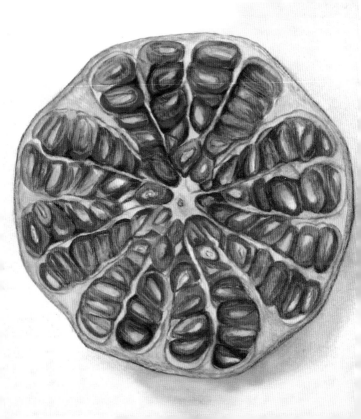

6

MISCELLANEOUS FRUITS

Fruits of this final chapter are not bounded by constraints of all belonging to a particular family or genus, or even of sharing a common name or part of a name. Unless that name is "miscellaneous fruits."

A number of these fruits come from increasingly far corners of the world. The increased interest in them in the latter part of the nineteenth century unfortunately also reflects the increased colonialism of that time.

Bananas (pages 271 and 272), for instance, were hardly known in this country until the late nineteenth century, following the establishment of plantations in various South and Central American countries by the newly formed United Fruit Company. The dark history of their practices can be summed up in the phrase "banana

republic," two words that speak to the worst of racism and propping up of dictators by the influence of self-serving corporations. Bananas went from being hardly known throughout the world to now being the world's fourth major food, after rice, wheat, and milk.

Look to northeastern Asia for the introduction of the Asian persimmon (see pages 277 and 279). Up until the middle of the nineteenth century, Japan was isolationist, which was not to the liking of US commercial interests. President Millard Fillmore enlisted Admiral Matthew Perry to ply American boats into Japan's Edo Bay to intimidate the Japanese and force them into opening their ports to American trade. Gunboat diplomacy proved a success. Asian persimmons, pretty much unknown here in the early nineteenth century, were among the many cultural and agricultural imports made possible by the "opening up" of Japan in the middle of that century.

Between the late nineteenth and early twentieth centuries, artists for the Pomological Watercolor Collection painted likenesses of over one hundred persimmons. Not all were Asian persimmons; North America is home to two native species, both of which have been enjoyed by humans and animals since time immemorial, and were among the native fruits for which there was burgeoning interest in the early twentieth century (page 278). A whole USDA bulletin was devoted to American persimmons, including a listing of thirteen of the "better-known varieties," none of which, incidentally, made it to a watercolorist's desk for painting.

Also in this miscellaneous grab bag of fruits are subtropical fruits of the Mediterranean region introduced into California and Arizona from Spain. Pomegranates were first brought here by Spanish settlers in 1769. They were grown on a garden scale by such notables as Thomas Jefferson and John Bartram ("America's first botanist"). Commercial interest in the fruit grew over the years; two thousand acres had been planted by 1920 in California, then interest waned until the end of the twentieth century. The major variety, Wonderful (page 281), that was planted a century ago is still the major variety grown today.

"Miscellaneous" also includes fruits not usually considered as such; that is, "nuts." Botanically, a nut is a dry fruit with a hard shell covering a single seed; the hard shell doesn't open naturally to release the seed. Acorns, chestnuts, and hazels are examples. (But excluded are cashews, pistachios, and almonds, whose fleshy covering groups them with drupes.)

Let's close with one of my favorite illustrations, that of walnuts, specifically English or Persian walnuts (*Juglans regia*; page 287), although labeled merely as "walnuts" in the drawings. A lack of any flamboyant coloration is more than compensated by the tawny shades and the intricate modeling of the surface of the shell and of the nutmeat itself, captured so well by artist Amanda Almira Newton.

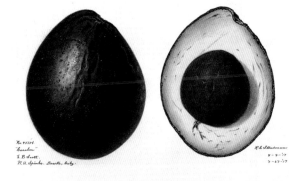

Carabou avocado (*Persea americana*), Los Angeles, California, 1917

Royal Charles Steadman (1875–1964)

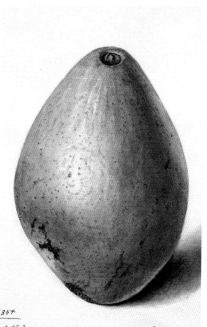

Estelle avocado (*Persea americana*), Dade, Florida, 1916
Mary Daisy Arnold
(1873–1955)

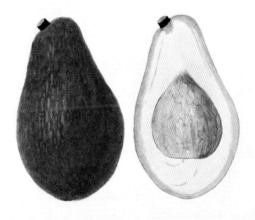

Perfecto avocado (*Persea americana*), Orange, Florida, 1937

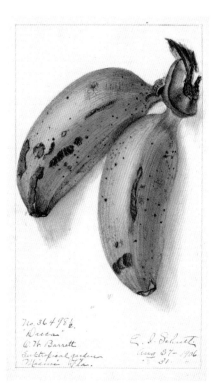

Dacca banana
(*Musa* sp.), Dade,
Florida, 1906
Ellen Isham Schutt
(1873–1955)

No. 36498b.
"Dacca"
O. H. Barrett
Subtropical garden
Miami Fla.

E. I. Schutt
Aug 37 - 1906
31. "

Yenjerto banana
(*Musa* sp.), Mexico,
1904
Ellen Isham Schutt
(1873–1955)

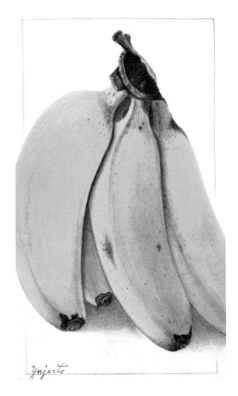

Ynjerto

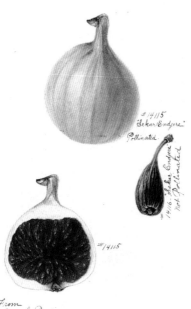

Sekar Endjere fig
(*Ficus carica*), Fresno,
California, 1897
Bertha Heiges
(1866–1956)

#14115
"Sekar Endjere"
Pollinated

#14116 Sekar Endjere
Not Pollinated

#14115

From
Geo. C Roeding,
Fresno,
Fresno Co,
Calif.

B. Heiges
8/14/9?

General Gordon
mango (*Mangifera
indica*), Dade,
Florida, 1904
Deborah Griscom
Passmore (1866–1956)

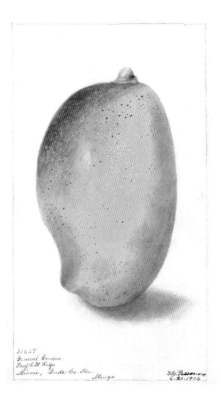

31647
General Gordon
Prof. C. H. Bute
Miami, Dade Co. Fla.
Mango

D.G. Passmore
6.20.1904

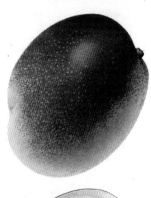

Hayden mango
(*Mangifera indica*),
Dade, Florida, 1923
Royal Charles Steadman
(1875–1964)

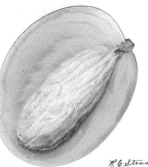

R. C. Steadman
7-23-'23

Peters No. 1 mango
(*Mangifera indica*),
Manatee, Florida, 1907
Amanda Almira
Newton (c. 1860–1943)

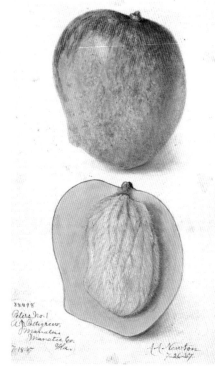

38498
Peters No.1
A.J.Pettigrew,
Manatee,
Manatee Co.
7-18-07 Fla.

A.A.Newton
7-26-07

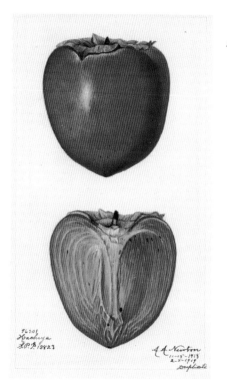

Hachiya persimmon
(*Diospyros kaki*), 1913
Amanda Almira Newton
(c. 1860–1943)

Ruby persimmon
(*Diospyros virginiana*),
Hendricks,
Indiana, 1905
Deborah Griscom
Passmore (1866–1956)

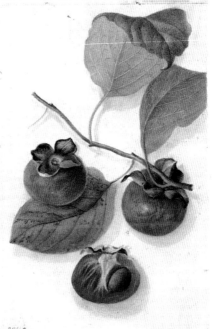

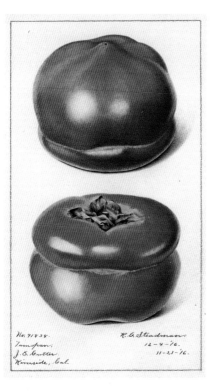

Tamopan persimmon
(*Diospyros kaki*),
Riverside,
California, 1916
Royal Charles Steadman
(1875–1964)

No. 71828.
Tamopan.
J. E. Cutter.
Riverside, Cal.

R. C. Steadman.
12-4-16.
11-21-16.

Pomegranate
(*Punica granatum*)
Amanda Almira
Newton (c. 1860–1943)

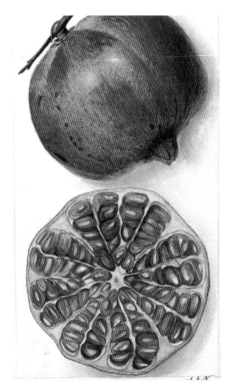

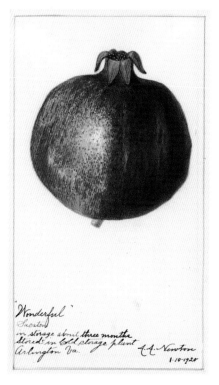

"Wonderful"
Sacaton
in storage about three months
stored in cold storage plant
Arlington Va.
A. A. Newton
1-10-1920

Wonderful pomegranate
(*Punica granatum*),
Arlington,
Virginia, 1920
Amanda Almira Newton
(c. 1860–1943)

Surinam cherry
(*Eugenia uniflora*)
William Henry
Prestele (1838–1895)

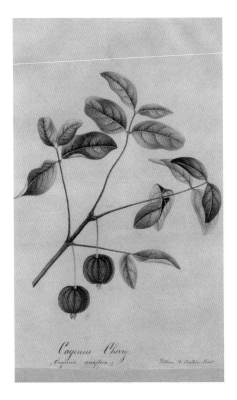

Cayenne Cherry
(*Eugenia uniflora*)

William H. Prestele, Pinxt.

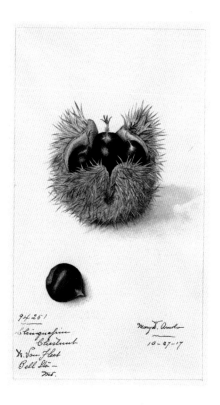

Chinquapin chestnut
(*Castanea* sp.),
Maryland, 1917
Mary Daisy Arnold
(1873–1955)

94251
Chinquapin
Chestnut
X. Van Fleet
Poll Sta—
ms.

Mary D. Arnold
10-27-17

Hickory (*Carya* sp.),
Louisiana, 1917
Amanda Almira Newton
(c. 1860–1943)

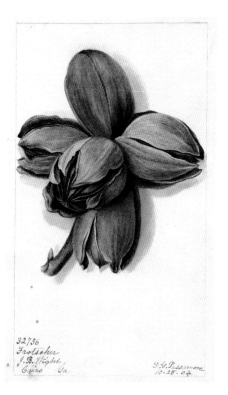

Frotscher hickory
(*Carya* sp.), Grady,
Georgia, 1904
Deborah Griscom
Passmore (1866–1956)

32/36
Frotscher
J. B. Wight
Cairo Ga

D. G. Passmore
10.28.04

Black walnut (*Juglans nigra*), Prince George's, Maryland, 1908
Amanda Almira Newton (c. 1860–1943)

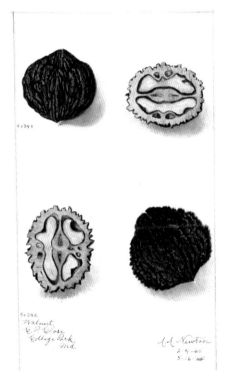

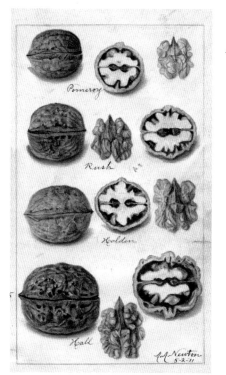

English walnut
(*Juglans regia*), United
States, 1911
Amanda Almira Newton
(c. 1860–1943)

SELECTED TINY FOLIOS™ FROM ABBEVILLE PRESS

Ansel Adams: The National Park Service Photographs 978-0-7892-0775-3

The Art of Rock: Posters from Presley to Punk 978-0-7892-0611-4

The Art of Tarot 978-0-7892-1306-8

Audubon's Birds of America: The National Audubon Society Baby Elephant Folio 978-0-7892-0814-9

Botanica Magnifica: Portraits of the World's Most Extraordinary Flowers and Plants 978-0-7892-1137-8

Classic Cocktails 978-0-7892-1381-5

Fashion: Treasures of the Museum of Fine Arts, Boston 978-0-7892-1380-8

Illuminated Manuscripts: Treasures of the Pierpont Morgan Library, New York 978-0-7892-0216-1

New York: Treasures of the Museum of the City of New York 978-0-7892-1361-7

Norman Rockwell: 332 Magazine Covers 978-0-7892-0409-7

Queens: Women Who Ruled, from Ancient Egypt to Buckingham Palace 978-0-7892-1401-0

Shoes 978-0-7892-1414-0

Treasures of the Art Institute of Chicago: Paintings from the 19th Century to the Present 978-0-7892-1288-7

Treasures of the Museum of Fine Arts, Boston 978-0-7892-1233-7

The Trees of North America: Michaux and Redouté's American Masterpiece 978-0-7892-1402-7

Women Artists: National Museum of Women in the Arts 978-0-7892-1053-1